THE ART OF EVENT PLANNING

Pro Tips from an Industry Insider

GIANNA CARDINALE GAUDINI

ISBN: 978-1-733119-60-3 (Hardcover)

ISBN: 978-1-7331196-2-7 (Paperback)

ISBN: 978-1-733119-60-3 (Ebook)

Contents

For my husband, Garrett, and my son, Giacomo, the loves of my life. I can't imagine life without your love, laughter, and smiles.

Prologue

As the event planning industry evolves, so do attendee expectations for experiences. In part, this is due to a growth of content and stimuli across all mediums, but it is also a result of the increasing role of technology available to enhance practically every component within the event and experiential spectrum. The pace of technology is progressing exponentially, so where does that leave event planners? For an industry based on human connection and creativity, how will new technological advances change the way planners operate?

Let me begin by saying that I do not believe there is any substitute for the raw authenticity of the human experience, regardless of the apps and technology that have aided both us and our attendees. Einstein once said, "It has become appallingly obvious that our technology has exceeded our humanity," however, ours is an industry where human sentiment will always reign. As experience creators, in the business

of making memories, we are continuously repurposing the ideas and breakthroughs of our predecessors and creating diverse, information rich, but intrinsically human experiences. While it is part of a planner's job to understand and utilize technology to elevate the attendee experience (everything from state-of-the-art seating to digital concierge services), we still must ground in human authenticity the events we create. This book offers a portal into the many components, purposes, and strategies for events. I've also included various personal development resources and frameworks that I've found useful to my career. While these are not unique to the field of event planning, they have played a key role in advancing my career and improving my "softer skills" as a leader. I believe these can be applied to any career but, in particular, will benefit event planners. My hope is they will help you develop into a brilliant event leader, and also the event planner of your life.

Whether you are just starting out in the planning industry or have a few years of experience under your belt, I'm a firm believer in having a growth mindset; there is always room for improvement in your craft as well as personal development. Communication skills are just as essential as the event credentials we bring to the table, so people of diverse backgrounds can succeed in a career in this industry. According to the "Big Five" model, widely adopted by modern psychologists, there are five basic personality dimensions that can shape us as individuals. Each of the Big Five traits —conscientiousness, openness, extraversion, neuroti-

cism, and agreeableness—have a cluster of related traits that shape our behaviors and emotions. Scientists have found that over the course of our lifetime, we often become more agreeable and caring due to greater emotional maturity. They also discovered that people working in professions that have a high concentration of human contact (teachers, coaches, managers, and *event planners*) tend to also grow in this direction. For many people starting out in event planning, the list of what is required from us will likely seem intimidating. Keeping an upbeat attitude, despite many tasks on an ongoing basis, develops with time as you come to realize that everything will get accomplished. A good career foundation includes the adoption of a growth mindset: a recognition that most of the necessary traits and skills can evolve with time and experience.

In time, if you haven't already, you'll grow to expect the unexpected.

You'll keep an impenetrable cool when an unforeseen twist arises (like construction on a neighboring city structure, loud enough to drown out a highly anticipated keynote). You'll hone your organizational skills, and your ability to juggle endless deadlines will appear effortless. You'll keep a high-level view of big picture goals, while paying attention to the smallest details as they fall into place. The purpose-driven decisions you make will impact those intimate gatherings as well as conferences with thousands of people as you navigate any situation as a focused event ninja. Someday you may stand before many as the leader of

a diverse, cross functional team. As you deal with everyone from vendors to influencers, clients to city advisors—your rapport will only continue to expand across a number of industries. You'll build your event toolkit and hone your communication skills as you work through problems and as you keep your eyes on the future.

I've always had a passion for sharing. Since I've been through the event planning gamut, others reach out frequently to me for advice, consulting, or the opportunity to connect. While I love mentoring, coaching, and sharing with others what I've learned and experienced, I found this model hard to scale, especially after having my son and having even fewer hours to myself each day. As a lifelong writer, I decided to summarize in this book the thousands of hours I've spent honing my craft, in hopes that you might discover my secret sauce for planning memorable, purpose-driven events.

I've planned everything from movie premieres to executive summits, conferences the size of small towns, women's events, leadership summits, incentive trips, concerts, product launches, and political events, not to mention more birthday and dinner parties than I can count. My experience has taught me why certain practices surpass others, and which personality traits are worth sharpening (like patience, dedication, and the ability to view a bigger picture while swooping into the details as needed). I've contacted a keynote speaker who returned my call while at Base Camp, halfway up his climb to Mt. Everest. I've

worked with A-list talent for movie premieres and produced events for the C-Suite at Google and other Fortune 500 companies. But some of my most memorable events were conceived from smart strategies tailored for social events and cause-related functions, even events I've hosted personally. I do believe we're all the event planners of our lives, and we can benefit from the skills we develop to create memorable experiences.

Whether in an event planning career field, or simply wanting to live a life by design, I hope this book will teach you to love the experience of ideating and producing. I still remember the time I taped an executive's shoes to his feet, so that he might skydive into the midst of an evening reception. I've seen the production agency hired for a major political event dissolve mere weeks before the event date and even figured out a way to maneuver a self-driving car into the foyer of a five- star hotel where guests were delighted in seeing it after the keynote. I've transformed a volleyball court facility into a beautiful event space worthy of my company's most senior female leaders and helped create personalized moments for tens of thousands of industry leaders. It comes as no surprise to me that "event planner" is chalked up to be the fifth most stressful job in the world, behind the likes of firefighters and soldiers. I constantly keep a running list of problems that might potentially arise and run through strategies for mitigating every possible challenge. I mention all this not to intimidate, but as a way to preface one outstanding point: Chal-

lenges are merely opportunities for problem solving, and when solved, they will add to your success!

Before we dive into the rest of the book, I want you to understand this key point: It's likely that you have *already* developed the core skills you'll need as a planner. Think back to your childhood and your dedication when playing a sport, practicing an instrument, or competing in speech and debate. Remember how you persevered when trying to master that string instrument, or maybe that austere piece of brass you took home to play behind closed doors (or perhaps in the open living room if you were one of the lucky few). The point is, the beginnings of your career can be intimidating, but you likely already have foundational skills that will lead you to success.

Here's an idea of what I mean—I can personally attribute many skills that make me successful in my career today to the countless hours of piano playing throughout my adolescence. I quickly came to love the melodic flow my fingers generated throughout my middle school and high school years. Devoting hundreds of hours to practicing piano, performing, and teaching my own students on Saturdays became a way for me to develop my discipline, poise, and an ability to calmly withstand pressure. For concerts, I would memorize up to an hour of classical piano pieces and perform in front of an auditorium full of people. Over time, I learned to control my nerves and maintain laser focus while pouring my soul and feeling into the keys in a perfect flow state.

The piano would sing at my command, and pieces

by Debussy, Chopin, and Schubert filled my life to the brim with their romantic melodies. I began to appreciate how my dedication not only affected the friends and family members that came to my performances to support me, but also the sea of strangers that knew me for only an ephemeral moment, but were made to feel something nonetheless. You've likely heard this claim before—that your childhood has prepared you in immeasurable ways—but it really *is* true. I still smile over the time my father came to tour one of the mammoth venues for a 25,000-person event I was producing, and his remark to something my executive said about my calm nature no matter the situation. With a smile, my father answered her comment with a quick insight: *It comes from the many years Gianna played as a concert pianist!*

Of course, there are so many other things that contributed to my decision to embark on a career in event planning (and pursue authoring books, too!). Perhaps one of my earliest examples is the time I started a neighborhood newspaper, the Bachman Park Gazette, in elementary school. I remember galvanizing my neighborhood friends to participate, and while we were never profitable with our venture, we *did* build a sizable following and were even featured in the San Jose Mercury News. One day, I decided to send a subscription for the BPG to the president at the time, Bill Clinton. When he eventually responded, my friends and I were thrilled. We wouldn't have received the envelope with the White House return address and the official seal had we not assembled together,

organized into factions, and written our respective pieces. While enthused, I wasn't equally shocked. Even at ten years old, I didn't consider myself a dreamer, but rather a go-getter with a plan. Throughout my youth and young adult years, when I fell in love with some wild idea of making something major happen, I would think about what it would take to make it a reality. This trait never died in adulthood, and I am still inspired to do more, and think bigger, today. I know you have this characteristic within you, too, which may be why you're reading my book right now.

If you haven't already, you will soon fall in love with the indescribable hum of energy inside a keynote session that hits just the right nerve within your audience. You will grow immeasurably moved after witnessing awestruck faces when attendees enter a venue you helped transform. When some executive taps you on the shoulder to compliment the local wines you handpicked to pair beautifully with the menu, the satisfaction is undeniable. This book will help you answer questions like, *What is the purpose of my event and how does that influence the strategy?* And, *How do I incorporate surprise and delight to personalize the attendee experience and move them to feel/think/do something?* I'll share my overarching tenets to producing a successful event, including how to select a venue bearing purpose and context in mind, how to successfully transform spaces and create an environment using principles of design, and how to engage attendees' senses with different tactics. I'll share anecdotes from my career, inter-

twined with learnings from companies I work with and love and resources that have made me more successful. I'll also provide career insights and recommendations for how you can make yourself more hireable by carving out a niche for yourself.

This book is also meant to be the catalyst that will serve you in changing passive attendee experiences into active ones. Not only will you become a storyteller and weaver of memories, but also a leader who drives action in the events you create. As deadlines grow shorter, and our attendee pool more diverse, even the most standard processes flex, but I have built a solid roadmap to serve as guidance. To be an innovative event planner, you must stay ahead of the curve as the world changes, and this takes constant vigilance and dedication. I congratulate you for starting a journey that will result in the creation of richer experiences, and I can only hope we'll cross paths and collaborate in the future. With seven billion people on the planet and counting, it is up to us to serve as the connective superpowers that keep everyone together and moving forward. What better mission could we have!

The earlier you start adding to your toolkit, the better your career outcome will be.

-Gianna

So You Think You Want to Be
an Event Planner

Making it as an event professional requires a unique set of skills, skills that can be developed and skills you likely already have. You might have honed them through a hobby or activity you've been practicing since elementary school. For me, it was playing piano that helped shape my aptitude for event planning and left me with diligence and poise under pressure. Think about what you enjoy, all the subtle talents you've been developing. List out the qualities that make you good at your favorite activities, or simply what makes you, *you*. You might try this exercise: Make a T-chart outlining innate skills versus learned. By the end of this chapter, you'll know how to build out this list by reinforcing current positive habits and by pursuing the additional skills that will aid you in your tenure as an event planner.

Some skills can be learned and honed over a long career, while others can be obtained via taking a class, attending a seminar, or reading a book. However, the

earlier you start adding to your toolkit, the better your career outcome will be. I believe there is nothing more critical to a professional planner's success than being able to see the big picture and lead execution with the final outcome in mind. In a successful event, everything comes together with precision if you keep the end result in mind and then create a step-by-step schedule, breaking down the complexities of the project into a manageable timeline. I like to start by asking the question, "What headline would you want written about your event?" This helps clarify the most important reason you're planning an event, especially if there are multiple goals to achieve. Having big ideas is one part of the process, but also critical is the ability to roll your sleeves up and see every detail through to the final hour. This takes in mind both establishing your goals early on and conceiving specific outcomes.

You can start practicing this on a micro scale today. Pick a small project that requires attention to detail, and see it through to the end. Reach out to your local community center—can you help plan a charity event? Coach a youth team? Help organize an elementary school play? My practice came in the form of planning dinner parties in college so that I might sharpen my cooking skills, but this plan soon evolved into much more. While I grew up cooking breakfast and baking desserts, I didn't have much practice putting dinner on the table (a skill my parents both perfected). This spurred me to set a goal for myself, to learn how to cook dinner dishes before I received my college diploma.

In the future, I wanted to be able to provide my family and friends the same fresh, home-made meals my parents made for my family. Shared moments were scarce between the many extracurricular activities my sister and I participated in and the hectic schedules my parents had while they ran their respective businesses. For this reason, family dinners were always a way to remain connected, even when spending time together seemed downright challenging. However, I knew that in order to replicate the sacred time my parents had established, I needed to learn to cook. While studying psychology as an undergrad at UCSD (The University of California at San Diego), I would invite a crew of my friends over to my college apartment, on Wednesdays each week, for complex dishes that I would prepare with gusto. Aside from practicing my cooking skills, I was adamant about providing great hospitality, too. The flank steak or gnocchi I'd prepared would slide onto the table amidst flickering candles, fresh cut seasonal flowers in vintage vases, and other decor inspired by whatever theme I'd envisioned for the evening. As guests arrived, they were greeted by the beat of soft music and the selection of wines and specialty cocktails I'd carefully chosen for the night (*kombucha and vodka was actually pretty good!*).

Wednesday evenings became the midweek panacea we would look forward to. I would head to a Whole Foods near UCSD main campus with ingredient list in hand, as my friends finished up their homework assignments. As our midweek tradition

grew, new guests would join the test-kitchen community. It became a great way to meet new people and share ideas while enjoying the coveted, home-cooked meals I'd learned to replicate. I soon realized how magical these shared experiences were and how much I enjoyed bringing people together to make meaningful connections and enduring memories. To this day, even after a long day's work, I take great joy in preparing a homemade dinner for my toddler before tucking him into bed, then heading back to the stove to cook up a fresh, healthy meal for my husband, Garrett, and me to enjoy and connect over. You might have a similar ritual that you're passionate about—but my point is clear: honing a helpful skill and practicing it consistently is a great way to squeeze the juice out of every day and prep for a wholesome life *and* career.

One of my favorite mantras is, "Create your own serendipity," and I find that this ties in with growing your toolkit and using it to your advantage. It's worth elaborating on some tools that have helped me develop my career. First, is manifestation, which is intentionally creating what you want, be it wealth, happiness, or your dream job. Manifesting has a lot to do with mindset, and I always coach people to keep an open, growth-oriented mindset. One thing I love to do every morning, to get into the right flow for the day ahead, is to go for a run before my son and husband have woken. As my blood starts pumping, I feel clarity in thought and spirit. This is the time I think through my priorities for the day, and when I return, I spend five minutes journaling. Psychologists

have found that writing down positive affirmations of what went well the previous day, what could be improved upon, goals, and gratitude is actually what makes people happier. Practicing gratitude could also be as simple as expressing thoughts verbally to your loved ones. It's not hard, and you really will notice a difference in mindset! By maintaining these practices, I'm able to manage the stress and inherent obstacles I'm faced with as an event planner and overcome them with constructive solutions.

I also believe it's important to write your goals down and create your own energizing mantras to remind yourself of what's most important. This is a key practice both for life and events. When things start to swirl, it helps you regain clarity and focus. Jot these down on sticky notes and post them on your bathroom mirror, your car's windshield, or wherever you look frequently. Writing things down will help you channel the energy you need to mentally move towards the accomplishments you hope for. Before working at Google, I made a list of fifty companies I wanted to work for. Google ranked number one. It might be true that luck has a hand in what we achieve, but once you take practical steps towards achieving your dream career, you'll be that much closer to seeing your dreams solidify than if you simply wish for things to happen.

If you're like me, you lead a hectic life filled to the brim with different things competing for your time. Even on the busiest days, I still think about how I'm spending my hours and even minutes. I consider

whether or not I'm being as productive as possible and what could be done to achieve a better work day. I advise you to look at your own schedule now, and consider the hours in your day that go by without any real purpose. Think about the lasting effect of every half hour you spend, consider which actions are moving you forward, and focus on making these habits. If you work out every morning and this gets you ready for the day, don't alter your schedule even if you feel overwhelmed by the week ahead. Since exercise delivers oxygen and nutrients to your body and is a proven method for relieving stress and beating burnout, this really shouldn't be eliminated from your agenda.

This has largely to do with the fact that when you give yourself time and space to breathe and think away from your desk, you have more mental space to tackle the day's tasks and make decisions effectively. Not to mention, exercise boosts creativity and problem solving abilities! The same goes for getting proper nutrition and plenty of sleep. A study by A.M. Williamson and Anne-Marie Feyer and published by the Huffington Post shows that even moderate sleep deprivation produces impairments equivalent to those of alcohol intoxication. After 17 to 19 hours without sleep, performance was equivalent or worse than that of a blood alcohol concentration (BAC) level of 0.05 percent. After longer periods without sleep, performance reached levels equivalent to a BAC of 0.1 percent, which is the blood alcohol level that would get you arrested for a DUI! Thus, event planners must

be keenly aware of the long hours they and their staff work onsite, not only to function properly, but to avoid accidents. I've never been one to pull an all-nighter, and I recommend you don't either. I've made it a habit to get to bed early enough so that when I awake for my 5 am run, I've had at least seven hours of sleep. I recognize my attention is at its peak in the morning, which is why I get to work early to put my heightened attention to good use. I've heard that others have the complete opposite pattern, and that might be true for you. Simply recognize when you're at your peak, and get your most challenging tasks done then. For instance, when I was practicing a particularly tough piano piece, I would rehearse and practice until I couldn't get past a passage without making a mistake. Sometimes I would fall asleep frustrated, but miraculously in the morning, I could play the particularly irksome passage perfectly, as if it had been ingrained in my memory. The brain has an amazing ability to improve clarity, memory, and new skills while we sleep, so skipping it will hurt your career, not help it! Sure, you might have to make sacrifices on the way to perfecting your most productive schedule, but everything is cyclical. Strain + rest + strain + rest = growth.

When manifesting your goals, it's okay to ease into your approach. For example, you don't need to overwhelm yourself trying to attend networking events every day if you're attempting to expand your network, but if you go to one event every two weeks and make a point of maintaining contact with one

new connection, that's a great start. New habits don't necessarily need to be hard ones, since additional add-ons to an already busy day can be challenging to maintain. Take the time to train yourself by approaching each desired new habit you want to possess as part of a longer process, rather than a "do it all now" task that must be accomplished in a month. If your goal is to become the best venue designer out there, studying a little each day will get you there in the long run. A run-for-ten, walk-for-five approach is less overwhelming than trying to cover sixty miles in your first week. As I learned as a distance runner, you can't finish a marathon without finishing the first mile.

Consider your daily activities too; do they make it easier to achieve your goals? I used to drive to the Google office and found myself chronically stressed while sitting in hectic rush hour traffic. Becoming a mother has made me fiercely protective of my time, and I'm always looking for ways to shave down extra minutes in order to spend more time with my family and hit work goals. Long ago, I started taking a ride-share to the Google office, so that I can catch up on my work on the way home. This way, I'm not answering any last emails as I spend time with my son or while cooking dinner. Changing the fabric of your day to reinforce positive habits will help keep you on track towards your goals. If you want to learn more about event diagramming or study up on another event tech tool, time box it (it can be as short as twenty minutes), and create a small reward for yourself after the period completes. When training a pet,

"positive reinforcement" is used to reward good behaviors (desired behavior), and it's a practice that works on humans, too. It may sound simple, but by rewarding yourself with a positive stimulus following a certain action, your brain begins to lessen its dislike of the arduous behavior. Adopting new habits and acquiring new traits is rarely easy, but perhaps a recurring piece of dark chocolate (or a hug from a loving toddler in my case) after a long study session can ease the process.

Once in a while, it's important to pump the brakes and shift your focus from hard skills and practices to interpersonal relations. Being able to connect and communicate with others is one of the most important qualities of a successful event planner. Though it might seem effortless when done well, communication takes focused attention to details. In fact, MRIs of the brain show that analytical and social thinking involve entirely different neural networks, operating like a seesaw with each other. When you engage in analytical thinking, the social part of your brain quiets down, and when you're finished, the social network springs back to life. When you're meeting with a client or colleague to pitch an event concept, more often than not their brains are see-sawing as they analyze whether the experience is going to satisfy their team's initiatives and whether or not you're the right person to help carry out the plan. This is one of the reasons why storytelling is a highly effective method for delivering content. As event and experiential planners, we're constantly weaving a narrative throughout our

keynotes and events at large. By controlling the narrative, you manifest what your audience takes away from your event and can move them to complete specific actions.

At one of the first agencies I worked for, I realized the importance of getting clients to feel comfortable in my presence within the first five minutes of shaking hands with them. The purpose of your initial meeting is not to sell a major event pitch, but simply to make it to another meeting which can then transpire into an opportunity to deliver your agency or company's value proposition. When you can find common ground or make people smile, their minds are more receptive to your ideas. Non-verbal communication is often overlooked as a key to connecting with others, but should always be considered a skill to hone, since it plays a much bigger role in making a connection with others than we typically attribute to it.

You might also consider thinking about how your gestures and body language could be interpreted. Facial expressions are a primary way to gauge how another person feels about your interaction with them, and are the easiest way to tell whether the other person is listening or mentally running through their "to-do" list. No matter where your counterpart's interest lies, always maintain eye contact, good posture (which means uncrossing your arms, which inadvertently puts other people at ease), and match the tone and pace of voice to the person you're speaking with. Enforcing these practices will help you

find a common body language, which in turn leads to better working relationships and outcomes.

On one particular spring morning, early in my career, I remember realizing the power of interpersonal skills when I found myself in the midst of solidifying a major deal for the agency I was working at during the time. The week prior to that morning's meeting, I had voiced a few ideas for how to build out a sales recognition event at a brand new venue in San Francisco, and now I was about to meet with a representative from the client's event team. I spotted a young woman hurrying towards me, a messenger bag slung over her left arm like she had just jumped from a cab in a rush.

"Hi—Gianna? I am *so* sorry I'm late!" she told me, stress visibly crossing her face.

I smiled back, and quickly answered that it wasn't a problem. I'd spent the time checking out the venue and finding a good place to grab a coffee for us, and besides, I understood how bad the traffic was this time of day.

The woman instantly relaxed. I noticed she carried herself confidently and definitely had a hip style made popular in San Francisco. I complimented the jacket she had on, covered in a variety of buttons and pins of varying themes, and recognized one from the Nike Women's Marathon I was also running in that October. Once we established a common ground, we fell into an easy conversation about marathon training. I kept asking questions, which eventually

turned towards the intricacies involved with the event ahead.

"Can you imagine the looks on everybody's faces when they see the surprise we have planned for them as they enter the venue overlooking Yerba Buena Garden? Not only will it be a tribute to the company's most recent ambitions, but it will also give the attendees flown in from around the world a sense of place —the perfect intro to San Francisco, where their new offices are being built," I said, turning towards the landscape below. I saw her looking in the same direction and thought about why I love the venue selection process. I knew this venue was the antithesis of dark convention center ballrooms of evening receptions in years past. The City View at Metreon was a perfect embodiment of the company's new cloud business, with open windows in an impossibly long stretch. Not only would it be an ideal space to welcome international guests and celebrate their sales achievements, but it would also showcase the heart of San Francisco—a city intrinsically rich with culture. As our conversation turned towards the weekend ahead, I felt a warm feeling. We had connected, and my vision had been passed off successfully; I had done my job well.

Sure enough, my agency won the business for the event in the end. My client reported to her team that she loved the venue, and moreover, the whole vision I had helped to create and pitch for the upcoming event. A truth seemed resounding to me at this time: we cultivate connection when we open up and let our

authentic selves through. We make a powerful impact when we listen and care about those we're working with and connect on a personal level. What makes someone comfortable isn't rocket science, but it does take a moment to decipher.

All this being said, you should never underestimate the power of getting to know different personality types. For this reason, I recommend taking a DiSC assessment if you haven't already done so, since it's a great way to see how you sync up with other personality styles. DiSC is a behavior assessment tool based on a theory developed by psychologist William Moulton Marston in the early 1900s. DiSC centers on four different personality traits and measures your behavior patterns, then assigns you a style. Rather than measure intelligence, the test is used to help people better understand themselves and others, within a range of normal human behavior.

The DiSC model discusses four reference points:

- **DOMINANCE** – direct, strong-willed, and forceful
- **INFLUENCE** – sociable, talkative, and lively
- **STEADINESS** – gentle, accommodating, and soft-hearted
- **CONSCIENTIOUSNESS** – private, analytical, and logical

Some psychologists believe that people's personality traits guide their behaviors consistently across situations. This is one reason why DiSC can be so helpful. After taking the assessment, you can learn to adapt your own responses depending on the style of other people around you. For example, when you become a manager, you might choose not to use the behavior you're most comfortable with, but instead adopt the style that you know will be more effective with individuals on your team. You will find that a DiSC assessment can cost anywhere between $24 and $100. This may seem like a lot of money to invest in an online test, but each personality profile comes with a multi-page, personalized report with tips and effective tools that are designed to help you save time, work efficiently, and recognize where/how you might differ with others.

If you haven't already, you'll soon realize the complexity of interpersonal forces that are responsible for the actions of those around you. A person's strengths, interests, and values influence them on a subconscious level, and play out in their work ethic, communication, and productivity. Identifying the styles of other people can explain why you might find yourself inclined to feel a certain way when dealing with sensitive subjects like conflict, project challenges, or differences in leadership strategy in your work environment. Get a jump on understanding the underlying reasons people are the way they are, and you'll earn yourself an immeasurable amount of respect. And always remember: There are very few

events that get produced without a team behind them; the better the team you build and maintain, the more successful you and your event will be. Your event is your baby, and just like with raising children, it takes a village!

Over time, you'll develop your own communication style—something no test can pinpoint. For example, I always let my clients know that when I'm working with them, we're entering a symbiotic relationship of trust, kindness, respect, and attention. This has remained an integral part of my personal style that I've worked hard to maintain to this day. I find that it is always important to maintain relationships with open communication, no matter what side of the business you're on. Whether you're interacting with a server at your event, or the president of a company, treating everyone with respect goes much further than you could ever know. I also believe that a kind note of appreciation does more than a tip or a gift any day, and when someone makes an impression on me, I never hesitate to send a heartfelt letter expressing my appreciation.

Have you ever heard someone say, "Trust is not something we give, or simply get, but rather it is earned?" I agree wholeheartedly. Trust is nurtured by asking someone how they're *feeling*, not just how they are. When a potential client shows up late to a meeting looking frazzled, it goes without saying that you should let them know you're not going to add to their stress level. Trust happens when you let the other party know that they aren't just part of your daily

routine, but rather someone you care about getting to know and being their partner.

Great relationships are formed early on when you choose to nurture with your words and suggestions, no matter if it's with a team member or someone you meet with for a fifteen-minute coffee break. Practice making strong connections early on, and you'll thank yourself later in your career. Understand that within two people there always exists some factor that unifies them. I've learned to look for ways to connect with everyone I meet, find them early, and never forget what bonds me with each professional I shake hands with. I make notes under their contact and then directly into a text app on my phone. Since a great connection can survive any amount of time, you must put the effort into making it strong in the beginning and catalogue a few of the person's unique identifiers. Unique relationships are one of the best parts about event planning.

A pro event planner must have a mindset that is constantly flexible to change and new opportunity. When you think far ahead on how a new piece of data might impact your target audience, your event strategy must adapt, but will strengthen as a result. Tending to your inbox puts you on defense as you answer client requests and questions, but it's just as important to stay on offense and map out priorities for the upcoming weeks. This could mean anything from managing your budget to reviewing creative event elements. Creating timelines and evaluating progress weekly has always worked well with my teams. Setting

deadlines is paramount, and I always identify uncertainty or risk factors that could affect the timeliness of deliverables and the event budget. I also schedule check-ins two weeks before each major team meeting. This allows for plenty of time to make sure stakeholder reviews can be scheduled and feedback can be given and implemented before my team convenes on the progress made. It also eliminates any frustrating rush fees or payment penalties that can be incurred if production deadlines aren't met.

Lastly, time management and the ability to prioritize is also key to a planner's success and something that becomes ingrained with experience. When I need to focus on a task like creating my planning timeline that requires my undivided attention, I turn to the Pomodoro Technique, developed by Francesco Cirillo in the late 1980s. The Pomodoro Technique is a time management method, and requires an individual to use a timer to break down work into intervals, traditionally twenty-five minutes in length (with no email checking or texting), separated by short breaks. It allows you to focus intensely, and then enjoy in a brief period of rest. Before beginning, I always assess the tasks at hand and quickly prioritize them. If I have to reach out to a vendor who is slow to respond, I do that first thing in the morning so that I can start tackling other items of the day, while I wait for a response. Having a zero inbox rule helps keep things manageable too— reviewing, responding or filing every new email helps you quickly ascertain whether or not something important has cropped up. If I'm out and

about and think of something pressing, I'll shoot myself an email and know that it'll be at the top of my inbox waiting for me once I'm back at my laptop.

As event planners, we must make hundreds of decisions over the course of a planning cycle. Assessing information and making decisions quickly helps move the program along, a key part in maintaining success as lead times grow shorter and tasks more demanding. In channelling efficacy, I carefully weigh the pros and cons of any decision, even if my gut instinct tells me something assuredly. I substantiate any important decision with data and challenge myself to keep an open mind until I have enough information. When making a decision, ask more questions than you think necessary, and gather information from as many sources as possible so that when you do pull the trigger on a decision, you can back it up. This might mean putting down a hefty deposit on a number of large tents for the concert you're planning when rain appears in the forecast, or perhaps changing the date of your event when you learn that your competitor's product launch event is taking place the day before yours. I always do a quick analysis, weighing costs and benefits, and come up with a few recommendations for how to handle a situation. When stakeholders hesitate to make a choice, I offer an insight-driven, clear path forward, and I also set a deadline to drive a reasonably swift decision (e.g., we need to approve creative renderings by Tuesday, otherwise we will incur production rush fees).

Though there is a lot to be learned, circle a trait

you'd like to work on in the upcoming month. Whether it be interpersonal skills, time management, budgeting, or decision making, take one step at a time towards perfecting your new learnings. This is a marathon after all, not a sprint!

Understanding your unique fit on a team will translate into a stronger performance.

--Gianna

2

Building Your Rock Star Team

Designing and producing an event—whether a conference, gala, convention, or product launch—is similar to preparing a five course meal at a Michelin star restaurant. Before you even think about preparing your ingredients or firing up the stove burners, you have to have a solid vision, a menu, and impeccable time and resource management in place. Every team member needs to know their specific role and own it. You'll need to work together with efficacy, and deliver with finesse to create the magic that earns the coveted Michelin star. In this chapter, I'll cover the different types of members within a high performance team and the core components of both evaluating and winning an RFP (Request for Proposal), which is always an important team endeavor.

No matter where you fall on the event planner spectrum, understanding your unique fit on a team will translate into a stronger performance for both you and your colleagues. For the purpose of this book,

and based on my own career learnings, we'll focus on the makeup of a corporate marketing/planning event team. This corporate event planning team can be broken down into three overarching groups: strategists, producers, and creatives. When combined, this trio is the secret sauce to producing a strategic, impactful, smoothly run and bespoke event. A successful team is both a melting pot and mosaic. Skills overlap within these groups, but some people are better suited to do certain things over others.

In the most general sense, strategists come up with a vision, producers flesh out the content and logistics to bring an event to life, and creatives develop the aesthetic foundation and detailing. Strategists may not be traditional event planners; they can come from all sorts of different industry sectors like business, finance, consulting, and marketing. Producers not only curate the content for an event, but they oversee the implementation of all elements leading up to the event day. They ensure everything is on brand, on budget, and on schedule. Creatives get tapped by both the producers and the strategists. They help flesh out a concept, render it dimensionally, and choose the materiality and color palette for scenic elements. Creatives might have experience with graphic design, user experience, interior design, and art direction that parlay well into the world of event planning. It's the job of all three roles to ensure your company or client's brand comes through, tying the strategy, creativity, and content together seamlessly.

While producers come from a variety of back-

grounds, they all share a key similarity: they *make things happen*. A producer has a multidisciplinary role and may specialize in different areas (like focusing on live-streamed events, or concert production). They need to be grounded with a strong eye for aesthetics, but have an analytical mind to be able to absorb insights, provide feedback, and evaluate solutions quickly.

Great producers recognize assumptions and challenge them. They are always advancing new projects and consistently ask the question, *Are we about to solve a real problem here?* Ad nauseam, they wonder— *Is this great idea possible? Can we produce it on time and within our budget?* And, *Will company goals be met if we proceed using this event as the marketing medium?* Producers understand the big picture but can also drive progress and make a concept tangible. They are eager to test everything— from concept validation to usability testing. You have likely served as a micro producer at some point in your life. Think of everything that has to come together to organize a wine-tasting trip to Napa with your friends or a birthday party for your spouse, for instance. You've had to take into consideration the types of drinks your guests enjoy and spreads that are utilitarian enough to satisfy every dietary constraint. While granular, this is one finite example of how a producer plans to make an event successful overall.

Strategists determine a plan for achieving key results. They ask questions like, *How do I engage a target audience in order to do X, Y, and Z?* And, *How is a live experience better for our marketing goals than a digital event, and how can we scale our live experience?* Strategists are contempla-

tive, systematic, and inquisitive. A strategist's line of responsibilities requires both creative and analytical thinking, powerful listening skills, and compelling persuasive abilities. In order to get to the heart of a problem, great strategists help align leadership teams with an impactful vision. They know how to get the information they need using different frameworks and formats. They inspire their teams to push towards specific results and don't stop until they get there.

Creatives devise the overall aesthetic of an event and sometimes develop a brand identity and guidelines. They design bespoke scenic elements and choose an overall color and materiality schema. Creatives probe into the finest details in order to make an event memorable, but they must step back from time to time to return to the overall strategy, keeping the brand vision at the forefront. They look at an event's production from different angles. A creative can ideate something that doesn't exist, but this rarely means their work is done. A creative might try a few different approaches while their fellow producers help them stay grounded, and either make a discovery or head back to the literal drawing board. If you don't mind constant iteration, and are inspired by breathing life into something completely new, then you have the makings of a creative.

Questions like, *What does this color and font selection convey to the audience?* Or, *Can we use these materials to create a more premium experience?* are part of a creative's daily thought process. If you have the ability to reorient yourself to the evolving landscape of your project day

in and day out, then you have what it takes for this role.

Whatever your role on an event team, you will inevitably contribute to a *Request for Proposal*, or RFP, at some point. If you're working for an agency, winning new business is a necessity, and an RFP is often part of the selection process. On the client side, you're likely the one creating the RFP for vendors or agencies to bid out your business, and you will need to evaluate everything from agency creativity to team structure, to your ability to operate within your budget parameters. In today's competitive landscape, both creating and bidding for an RFP is a core component of the event planning process. While using an incumbent agency to produce an event has its advantages (you are already familiar with their team and work style), requesting proposals from new agencies is an important part of keeping the pool of creativity inspiring your events fresh. When you understand the critical principles involved with navigating the RFP process, you'll also be setting up the framework for a successful partnership.

There are various reasons companies choose to create and deploy RFPs when deciding on vendors and partners. For example, they're hosting an event in a new city and do not have an established track record with venues and a firm grasp on the culture of a certain region. A company might also be searching for new agency partnerships for other reasons, like more

competitive rates, fresh perspective, or some specific reason, like an agency that is adept at working with influencers or large scale conferences. On a macro level, the company submitting an RFP should let an agency know as much about their goals for the event as possible, reducing any uncertainty about tasks ahead of time. Remember—the responses you get for an RFP are only as good as the brief written, so if you're not clear about something when creating your RFP, chances are, your agencies will not be successful in submitting their proposals either. An RFP should include details that set constraints for planning, budgeting, and measuring success, such as the size of an event audience and the market segment the company falls into—either corporate, governmental, non-profit, product launch, experiential, or social. The sales team at hotels and convention centers generally have specific staff groups defined in these segments. Clarifying one means an agency will be able to quickly get in touch with the most qualified person for your event at a particular venue or hotel.

If an opportunity presents itself where you can bolster relations with a prospective agency client, by all means, take it! It's hard to get a holistic under-standing of an agency's capabilities and unique quali-ties as a partner after undergoing just one RFP process. I often take the opportunity to see a new agency's work or catch up with core account members over drinks or a meal, and get a better idea of their modus operandi. If you enjoy spending time with agency members, it bodes well for your future collabo-

ration. Who do you want to be in the trenches with? Take some time to figure out who key agency members are. You will never regret it.

Recently, I was reviewing a capabilities deck sent to me from a new agency and noticed that they had produced a very well known women's conference. When I registered for the conference several months later, I made a point to get in touch with the CEO of the agency. It was much more valuable to have her walk me through the event and respond to my questions in person, than if I had made a judgement on their work solely from their capabilities deck. Afterwards, I walked away with much more insight on how their agency executes, since I had witnessed everything as an attendee. When evaluating any vendor, I encourage you to inquire if there's any opportunity to see their work live; whether it be a caterer, a musician, or agency team—there's nothing better than experiencing a professional's work in real life.

When I was working for an agency in the earliest years of my career, I would volunteer my time to work with industry professionals I admired or had met at networking events. I always asked how I could be of assistance at one of their upcoming functions. Not everyone had an opportunity for an extra hand, but when given a yes, I kept my mind open to handle any task thrown my way. Sometimes this came in the form of meeting and chaperoning speakers and talent, overseeing catering, organizing gift bags, or welcoming the first guests that arrived onsite. From these different vantage points, I would often find

things that could be improved upon. I made sure I had a few solutions before bringing them up to the client in the spirit of being helpful and offering a fresh perspective. When I did, our conversations often expanded beyond the event itself to future opportunities. The old adage, *getting your foot in the door* is a start, but really, getting your ideas across and being effective at building relationships is what propels you forward in this industry.

I quickly garnered a crucial understanding of how to build my value effectively by attending industry events and networking meetups. In keeping a focused approach, I thought about what a company's pain points were and how I might bring these up in an organic conversation with potential partners and decision makers. It's a good idea to research who might be at a networking event ahead of time, so you're not going into your first conversation with an important potential connection completely blind. It's helpful to set a goal for how many people you wish to meet, and keeping this number under five helps with the quality of the meetings. Speed networking isn't recommended, since people can certainly gauge inauthentic intentions. One trick that works well if you can't figure out who will be attending the networking event ahead of time, is checking a company's social media once you see their name on the registration list. Before approaching the person you'd like to connect with, arm yourself with a conversation opener that's sure to stir up meaningful conversation. Something like, *I read the article you wrote on LinkedIn and*

notice you're gearing up for a new product launch… I'm inter-ested in hearing your opinion on how you'll promote audience engagement before the launch? is a much better way to grab someone's attention than talking about the weather.

Showing decision makers that you have an authentic interest in their company's future is impor-tant while you have their attention. It makes perfect sense that neuroscientist Paul Zak discovered that meeting new people triggers oxytocin in the brain, the same generosity-trust chemical that is produced when you're falling in love. When you go a step further and ask specific questions that catalyze a memorable conversation—you're that much more likely to receive an RFP when the time comes.

Another way to remain authentic when networking is to associate with people you genuinely *want* to learn from; whether you need a quick gut check or ongoing career guidance, ask questions of people you've rubbed shoulders with that seem inter-ested in giving back to other planners. Another great way to make an impact is to learn how others have done so. Being new to an industry doesn't put you at a disadvantage; rather, it offers you a larger window of opportunity to explore and grow. I've found progres-sion comes from immersion, so ingratiate yourself in conversation about events of all types, and don't hesi-tate to explore where a connection might take you. On the flip side, if you find that you're the most seasoned planner in the room, stay open-minded to learning from younger team members and the unique

insights they may be able to lend. On both sides of the table, there will *always* be learning opportunities.

The time will come when you've successfully secured your agency an RFP. Now it's time to make note of what content the proposal focuses on, and whether or not there are any details left out. Typically, an RFP lists the top three to five things the organization hopes to accomplish from their event. If objectives aren't outlined clearly, it's the agency's job to extract this information before putting together a pitch that will successfully address what a company hopes to accomplish by the end of their event. Try to work through a SMART outline, famously defined in Peter Drucker's *Management by Objectives*. I'll save you some reading: In order for an objective to be accurately measured it should be: Specific, Measurable, Achievable, Relevant, and Time bound (time limited, time/cost limited). Use your own insight to delineate the areas which will need more focus given the specific nature of the event.

SMART objectives will ultimately guide and help an agency align their overall event strategy. More effective event objectives may include:

- Increasing attendee engagement through social media
- Product engagement
- The number of event RSVPs and onsite attendees
- Ticket sales and revenue
- Trainings and certifications

- Sponsorships sold

Look out for budget guidelines too, and whether these take into account taxes and agency fees (these alone can amount to over 25% of a budget!). Be especially careful when allocating budget to food and beverage (F&B). Does the allocation include crew meals, staff meals, tax, service charges, and gratuity, and all-day beverages? If a company says their F&B budget is $40,000, it's the agency's job to decide if this number is realistic given the number of guests/crew/staff, quality, and scope of what this includes. But before telling a company that the budget is too low, an agency should make an effort to come up with creative solutions while setting expectations for what can be delivered. Perhaps it makes sense to bring in outside wholesale snacks and nonalcoholic beverages, or consider corkage service to save on pricey wines. Or a solution I use when working with a lower F&B budget might be providing an alternative option for crew members like bringing in food trucks or providing meal tickets to a neighboring food court. Other things to consider when building out a budget response include offering the client a discount if they can agree to a larger scope of business, or an ongoing partnership. Questions like, *Is this a one time event, or are you looking to host it again?* can help begin a dialogue that ends with a happier client *and* agency team since more work means more business for an agency and upfront discounts on certain agency services for a company.

Ultimately, the company sending an RFP should

strive to make sure an agency understands their needs and what they value in budding business relationships. On the client side, I always want my RFPs to be as clear as possible to give agencies the best possible chance of succeeding. If an agency doesn't end up winning an RFP, I take the time to debrief with them and review the reasoning behind the decision. If you are on the agency side and have lost an RFP bid, don't give up hope of ever working with the company in question. Rather, find ways to stay in touch in a useful way. Perhaps this translates into offering to attend one of their events and performing an audit to determine areas to improve upon. Finding opportunities to stay in touch with the decision makers can be as simple as sending thoughtful articles along, or introducing new ideas or vendors that you think could help their events. Think of the long game; there are times when it's not possible for a company to go through the RFP process due to timeline alone, but if your agency is on a decision maker's radar, you might be afforded an opportunity for collaboration without even having to go through the RFP process.

Dividing a customer base using segmentation can help you customize the right experience for each attendee.

--Gianna

Defining your Target Audience

Imagine you're walking down the street and a random person stops you. They ask, somewhat forcibly, if you want to buy a scarf. They don't wait for you to mumble an excuse—you have to get to work, rush to a meeting, leave the country, really anything else rather than talk to someone so pushy. They completely ignore your reluctance to talk to them, and keep shoving the scarf in your face. The reality is, you could probably spare a few moments to talk to this person, but you don't want to. They are invading your space, and there's no chance you can experience their product on your own terms.

Sound familiar? Although we already know that this type of selling doesn't work nine out of ten times, it still happens in the form of prolific email marketing campaigns and cold calls. Consumers are suffering targeting torment more than ever before. As online response rates have dropped, the reaction has been to target consumers more frequently and intrusively. I

gained some interesting insights from Millward Brown's AdReaction Video report, a 42-country study, which provides genuine insight into the perils of audience targeting. Consumers have a highly negative reaction to targeting that is perceived as intrusive stalking, but a more positive response when targeting is based on relevance and topics of interest. The AdReaction Video study demonstrated that giving people more control over how they're served ads increases receptivity. YouTube's TrueView system, which is available through the Google Ads platform, is a good example of one tool that allows people to have more control over their interaction with brands. Between the in-stream and display models, advertisers choose which format best fits their specific customer base. In response, viewers have a less intrusive experience overall and are less likely to turn off, or switch mediums.

The feature comes at a time when failing to give consumers control comes at a very high cost. It was recently estimated that 70% of Europeans will be ad blocking in 2020, and Americans are set to hit the same level by 2022. Just as in the street vendor example, people go into defensive mode when someone bombards their personal space with sales pitches, and it's our job as orchestrators of experiences to take a strategic approach when promoting events. I always applaud the marketers that are able to reach me in a relevant and valuable manner with pull rather than push tactics. This might come in the form of a helpful blog post or a free downloadable meditation app after

I attend a wellness event. However, in order to strate-gize where a target audience for an event will most effectively absorb a company's messaging, you'll have to first build out a target audience profile before defining natural ways to enter their days in as helpful a way as possible.

Let's briefly refresh on important terms. A target audience is the demographic of people most likely to be interested in a company's services or products. If you work for a wedding planner and are hosting a promotional event to make your company known to the surrounding area, your target audience will likely be as simple as men and women in their late twenties and early thirties. On the other hand, if you work in-house for a cloud computing company, the target audience for your upcoming conference will be much more specific and likely segmented. Once you have an overview of whom you want at your event, creating segmentation will help delineate a more personalized experience for each group of attendees from a marketing standpoint and when fleshing out the event details.

In short, segmentation is the practice of dividing a customer base into groups of individuals, but you decide the criteria for creating these demographic groups. I managed one event for thousands of atten-dees where there were inevitably many audience segments and a diverse audience pool. A CEO in attendance would have a different experience than a practitioner, since each segment member has certain needs. The CEO would likely be interested in

networking with other executives, and the practitioner has more need for training and in-depth breakout session content. Consequently, they had their own tailored track from which they glean value while at the conference. It's important that we make sure the event is promoted in accordance to their interests.

Other segments included partners and sponsors, press members, industry analysts, and women in technology. Specific activities, content, and programs were developed for each segment to make the conference more relevant and engaging to each type of attendee. For our female demographic, we created a lounge with confidence coaching stations, headshots, and custom programming geared toward women in technology. We also hosted a private reception and breakout sessions specifically relevant to their community's needs.

Segmenting also helps develop appropriate breakout session topics, and can provide insight into an audience's wants on a finite level. Breakout sessions and trainings are a great way to offer attendees access to the type of content most tailored to them, while networking with similar minds. Breakout sessions can also offer an opportunity to drive focused industry innovation—and at the very least, are a great way to gather primary data for next year's event, i.e., what areas seem particularly interesting to each segment.

Since a company's target market is dynamic, the way an event is marketed may change from year to year. For instance, over a year's time, a company might want to expand and sell internationally. Of

course, this will change the pool of attendees they'll target for that year's event. One way to satisfy a new target audience without substantial primary data from previous events is to leave certain elements of the schedule open-ended and offer choices for attendees to choose from: i.e., training options, breakout sessions, keynote viewing, and lunch options.

I've often used survey data from the previous year's event to find areas for improvement. For one large event, there was room to improve the food offering, so rather than use the expensive and lackluster catering service provided by the convention center's exclusive caterer, I thought creatively about how to achieve the massive challenge of feeding 30,000 attendees outside of the convention center. On many site visits, we'd passed through the food court at the Metreon venue, which housed breakout sessions and other private events at the conference. At one point, I asked whether we could possibly rent out the food court, using the food vendors to offer limited menus to our attendees. After months of negotiation, my team was able to secure the entire food court to use for our attendees' lunches, offering a delicious array of meal choices at scale, and at a better rate than the alternative convention center catering option. Since we are all creatures of comfort, offering a wider selection of food and locations to choose from could mean the difference between an attendee making it to their breakout session on time or missing it while hunting down their preferred meal. In addition to offering up tasty options at the Metreon food court, we created a

fun environment at Yerba Buena Gardens, where we passed out picnic blankets so that people might mingle together outside, taking a few minutes to recharge between sessions. DJs played upbeat music which gave off a "festival vibe" that resonated in particular with the developer demographic. Private lunches were held for certain higher-touch groups, and "magic moments" were incorporated through the campus in the form of hot dog trucks and ice cream carts. In offering a wider array of options during mealtimes, we achieved a higher level of interconnectivity between attendees. It made everyone feel welcome and helped us reach personalization at scale. Whatever mealtime provisions you choose, offer as many dietary options as possible so that you account for a wide array of preferences.

You will likely set up events for companies that market to businesses or consumers, and sometimes companies that cater to both audiences. Companies that market to businesses are typically concerned with connecting with decision-makers prior to the event. They will target companies in either the public or private category, certain regions, and for overall buying patterns and needs for distinct technology. I find it best to break out B2B into vertical or horizontal segments. The benefit of vertical segmentation is that companies can offer services that are fine-tuned to particular industries. The needs of the financial services industry can be different from those of the healthcare industry. If each segment is marketed to in relation to their particular industry, you can expect

they'll have more interest in your event. In horizontal segmentation, companies simply focus on one job title across a wide range of industries and organizations. Marketing through horizontal segmentation for events puts a stronger focus on the needs of particular job titles or job roles. For example, if a company has created a product for Chief Financial Officers, their event marketing tactics might center on bringing in a speaker that has industry-wide prestige, rather than a pop singer or social media influencer.

When I plan an event for a B2C company, their target audience will fall into segments defined by consumer's attitudes, demographics, and lifestyles. B2C companies tend to also be concerned with geographic location, since this customer segment can demonstrate certain regional preferences and offer insight into target attendees' behavioral segmentation. Though somewhat of a less quantifiable approach than others, defining this segment comes down to identifying certain attributes like brand loyalty, knowledge, awareness, purchasing patterns, and social media engagement. Although under the same flag, American behavioral styles could not be further apart regionally. I find it interesting that researchers from the University of Cambridge analyzed personality traits of nearly 1.6 million people living in the United States, through their social media channels, and found gaping differences in populations. They looked closely at five personality dimensions—agreeableness, neuroticism, openness, conscientiousness and extraversion—over a span of twelve years, to see how they

mapped out throughout the country. Their findings were fascinating; they showed that "friendly and conventional" traits are the most common amongst people living in the South and North-Central Great Plains region, while "relaxed and creative" were the most common traits for people in the Western and Eastern coastal areas. New Englanders, on the other hand, were most likely to possess the traits of temperamental and uninhibited. Of course, these regions have a smattering of all personality types, but you get the picture: there *are* patterns within regions of the US to look out for and cater to with your acquisition tactics. I've observed that different demographics tend to arrive at my events at different times, providing me insights I can use to strategically plan around their patterns. For example, I've found folks in the education sector tend to arrive early for events, so I often advise my staff that we need to have registration and catering set up thirty minutes before the published start time. On the other hand, at my CXO summits, attendees tend to arrive just ten minutes prior to the start of keynote, so I've learned to build buffer into my schedule following the keynote to allow for a delayed start time without derailing the rest of the day's timing.

With both business and consumer focused companies, using inbound perspectives will increase the overall interest in your event. The creation of blog posts, videos, seminars, and ebooks will help a target audience discover your company organically. Circling back to the beginning of the chapter, consumers will

respond to a brand that shows them value. If they see a ticketed event for a company they regularly turn to for expert advice, chances are, they will share the event link with friends and generate awareness organically. Just think back to the last time you chose to attend an event and what was going through your mind. When you attract customers early enough with valuable information and customer service, you are going to win more than a sale, rather, a customer for life. With value comes happiness, and with happiness comes loyalty. The industry gurus that have nailed this understand that this paradigm lasts a long, long time.

A number of emerging tech companies have revolutionized the process of event lead management between attendees. If you can connect with attendees before your event with relevant content, you are showing your target audience value before they even set foot in the venue. One company that has successfully cracked the code for tracking the important conversations at events, is atEvent. They do a good job of event lead management covering the entire cycle of an event. Before the event, you can customize their mobile app with qualifiers that will help you get a deeper understanding of your leads' needs and where they are on the customer journey. During the event, sales reps can use the mobile app on their phone, eliminating the need to rent scanners, then assign follow-up actions, such as sending a testimonial to a lead. Further, these leads can be automatically enrolled in targeted nurtures based on their customer journey stage; hot leads are routed directly to the sales

department, who go on to use the context captured at the event to engage the prospect in a meaningful way. And finally, once the event is over, a company can use atEvent's analytics to identify trends among attendees and target accounts and fine tune their account-based marketing strategy. This is a great example of a company that is connecting the dots between events and other demand generation efforts, so all those great conversations at the event can turn into meaningful engagement after the event and have a lasting impact on a company's bottom line.

Technology aside, humans will always have a hand in providing value to prospective attendees during the acquisition period. However, before you even begin the complex audience acquisition journey, I advise you to pause and determine whether or not an event is the best strategy for your company. While hosting your own event can certainly generate new business opportunities, it can also be incredibly costly. With complexity in mind, it's important to assess whether or not an event is the best marketing medium for your company. Most importantly, define what your overall goals are for the event. Goals could be: driving brand awareness, gaining sales leads, educating employees, or even boosting employee morale. In order to maximize the impact of an event strategy, these goals need to be specific. If one of your top goals is to generate leads from a niche audience, smaller guerrilla marketing event tactics might be more effective than

planning a much larger, more costly event. Another option is to assess third party events that are interested in partnering with your company to maximize your exposure without the overhead of creating a complete event from the ground up. Digital marketing and content creation are some of the most effective approaches, and reaching out to influencers can result in organic blog posts about your event and your company's products and services. Whatever choice you make, I do believe bringing your target audience together and interacting with them one-on-one is critical to a brand's relevance and growth. By thoughtfully planning live engaging experiences leading with the customer or consumer, you will invoke brand affinity, and a return on your investment.

Everything you plan should correspond with your overarching messaging.

-Gianna

Honing Your Event Strategy

We've covered attendee acquisition strategy, but what about tactics for making an event truly impactful? With so many details to pull together—attendee acquisition, content, experiential elements, F&B, scenic, social engagement, entertainment, color scheme, swag—it can feel overwhelming at the outset to come up with a distinct strategy to keep your event cohesive. However, with a blueprint in place, the strategy and iteration process becomes much more manageable.

We've touched lightly on this, but it's such an important step that it's worth mentioning again: *prioritization!* I start the planning process by defining the top *three* elements that matter most at my event. For instance, when planning my wedding, my husband Garrett and I decided that we wanted great food, a truly unique setting in wine country, and a meaningful ceremony with participation from our friends (a terrific band also made the top of the list!). Once

these factors were agreed upon, we knew how to allocate our budget, and this guided our decisions and eliminated many late night headaches. For instance, when it came time to sourcing a venue, we knew we wanted to be able to host the reception outdoors with a spectacular view of wine country, which helped us prioritize Auberge du Soleil over a venue that would have provided more seating but less breathtaking ambiance.

When it comes to a corporate conference, goals may shift, but should be defined and redefined year after year. Perhaps your goal is to scale the total number of attendees one year, and training attendees the following year. Everything you plan should correspond with your overarching messaging. In line with an education or training strategy, you could try supporting content in sessions with hands-on labs or opportunities to meet with product experts. When designing an event layout, be certain to allocate more space for these learning activities if that's your primary goal. It's also important to promote these features through your marketing channels and let your attendees know the value they'll receive at the conference, while allowing them to sign up for their sessions of choice in advance.

The beauty of doing an event for the second or third year is that you have enough data to comb through for aiding decisions. There should always be a well-designed process for collecting and recording data throughout the event process, and a great medium to generate feedback from your event is a

post-event survey (and in some cases also a pre-event survey for comparison). Surveys should be created with your goals in mind; i.e., if you want your survey to inform next year's budgeting, make sure you include questions that will generate these responses. If you want to measure your net promoter score (NPS) you should utilize a Likert scaling system. A Likert scale measures the strength of an experience on a linear continuum, from strongly agree to strongly disagree, and makes the assumption that attitudes can be measured. By subtracting the detractors from the promoters (which the scale measures), you end up with your net promoter score. Your NPS is a great measure of your customers' overall perception of your brand, and it is a leading indicator of growth. I also encourage you to think about the amount of time a survey takes to complete, and advise giving attendees a timeframe (i.e, it will take 2-3 minutes). Showing a status bar can also serve as motivation to complete the survey. Finally, add open-ended response questions into the mix. These will help you glean valuable insights from attendees that list choices may not evoke.

After any event concludes, I personally sift through survey responses and dissect the answers, keeping an eye out for patterns. Armed with data, I create the next year's event survey, that in turn will ask the appropriate questions needed to improve the coming year's event. This cycle is incredibly important for companies, since repeat attendees will take note

that you listened and responded to their concerns, and new attendees will benefit from the improvements.

Aside from the overarching strategy, you may have secondary goals that you can achieve pending resources, time, and budget. These should be tackled once the primary objectives have been planned and can enhance your event when done thoughtfully. At Think Auto, we were hoping to give our attendees access to Google's new self-driving cars, but didn't get confirmation that one of the cars would be available for our event until a week before the event. It was great news, but also posed a bit of a challenge; we had 250 people attending the event, but only enough seats and time slots for sixteen people to go for a ride, since the car was only available for an hour during the planned lunch. I came up with the idea to have an "Oprah moment" right before attendees broke for lunch. We created sixteen car-key-shaped "golden tickets" which we hid randomly under the seats in our keynote room. This created an unexpected moment of surprise and delight for the lucky guests who had the keys under their seats, and was an equitable way to approach the dilemma of which guests would get to test-ride the car.

Similarly, at Think Cloud, we were planning a breakout session where attendees had to whiteboard solutions and then present them to a panel of judges. We wanted a fun incentive to motivate attendees and reward the winning team. This was around the same time the new Tesla sedans first hit the market, and opportunities to test-drive them were in as high-

demand as Elon Musk himself. Since the same demographic that was attending Think Cloud overlapped as potential new clients for Tesla, I brokered a partnership with their sales team to bring four of their new electric sedans to my event for the winning attendees to test-drive. The four shiny Teslas were parked in front of the event venue for the entire day, and I watched as guests admired and discreetly took photos with the cars (remember, this was the very early days of Tesla when they were rare to spot). Right before the pitch-session, we announced that the winning team would have the opportunity to test-drive the cars to our evening event; the excitement was palpable! As a consolation, I hired electric cable cars, a San Francisco specialty, for the rest of the attendees to take to the event. After all, I always aim to provide delight to *every* attendee.

When developing the "edge" that draws attendees to my event, I find it helpful to create a mood board around my strategy. Creating an inspiration board with both high-level and intricate details that evoke the look, feel, and narrative of your event is one way to start visualizing how all the elements of your event will come together. Mood boards are also a great way to test the aesthetic of an event with my stakeholders and evaluate their reaction to the style I'm proposing, before burning through design hours on digital renderings. They're also a great medium for distilling the many unique elements of an event in one place and making them easier for stakeholders to comprehend at a conceptual level. Planning the strategy for

an event involves taking everything you know about a brand and bringing it to life using elements from scenic, colors, materials, activities, music, food and beverage, and even signage. When looking at imagery, I advise you to think about what feeling certain fonts, colors, or styles evoke. These factors help you break down why your company or client's brand differs from its competitors. I often use the rule: If this looks like it could be any other company's event, let's start over on the design.

If you're in an agency, mood boards can also be really helpful with ensuring that you and your client are on the same page before you start the creation process. If you're planning a social event, you might ask your client to pin twelve to fifteen photos that represent their tastes and wants for their event. Ask *many* questions to get a specific direction in this early stage—*Are these materials too formal/informal? Will this seating plan allow you to accomplish the goals of your event? Does this stage match the level of production you're planning?* Once you have nailed down some initial constraints, you can hone in on the best way to accomplish the goals of the event, and save time, money, and likely, your sanity.

No lie, one of my least favorite aspects of events is swag. But it's a ubiquitous element of many events, so let's touch on it. Whether you refer to it as branded merchandise or promotional products, giveaways with logos can be a cost-effective ad medium if sourced strategically and extend your brand life beyond the event. However, to make the most of a swag handout,

just like any other element of an event, you need a strategy. Swag can represent your brand in a way that no other advertising medium can—with a physical item that people take with them after the event concludes. At a recent event I hosted, we were hoping to increase our survey response rate year over year. Rather than distribute the logo'd event tee-shirt at registration to attendees as we'd done previously, we incentivized attendees by distributing the shirts only to attendees who completed our post-event survey. The minute we opened up for business, we had a massive line, and people were willing to wait up to thirty minutes to complete the survey for their swag. The results: Our survey response rate was 625% greater than the previous year!

You'll sense a theme here—as in every other part of the planning process, begin your quest for the perfect swag with a list of goals. Do you want attendees to return to your event year after year and collect a new tee-shirt, which they'll go on to wear throughout the year? Do you want to give away a high quality item that can be used in perpetuity, like a leather laptop cover? Do you want to get your company's products, perhaps a new hardware device, into the hands of attendees and influencers? One great example of how I used swag strategically was the Think Event Series app integration. For the Think Event Series in 2013, we developed a bespoke app that was so successful, it went on to win the Event Technology Gold Award for Best Use of a Customer App. The app helped us achieve many of our goals by

incorporating gamification, a trend we'll see more of in the future. Attendees downloaded the event app and earned points that they could redeem at the end of the day for various types of event swag. You'll be surprised at how well this worked as an incentive -- we had an incredible 89% download rate! Attendees earned points by completing tasks that met our goals such as submitting a question for the presenter, scheduling a meeting with a sales rep, completing the event survey, or engaging with one of our product demos. At the day's end, attendees redeemed their points for swag which we packaged up nicely for them in a custom logo shopping bag and distributed to them as they departed the event. This is a great example of how technology, coupled with a tangible incentive, can engage your attendees *and* meet your goals.

When choosing giveaways, avoid any cheap, low-quality options, and think through what the attendee will do with it. I also recommend finding something that is not only useful for your specific attendee demographic, *but also* has positive messaging ingrained in the item's fabric. Fair trade products are a great example of unique and responsibly sourced goods. Fair trade is an institutional arrangement designed to help business owners in developing countries solidify better trading opportunities. Another route to take is handing out options that promote sustainability, like tee-shirts made from recycled materials. At large conferences, I like to provide water bottles as a staple swag item, so that attendees can use these rather than plastic bottles and cups during the conference, and

also when traveling home afterwards. Even going so far as to provide your attendees with a credit to make a donation to a charity, or a code to select a gift based on their own preference from an online store, will generate positive responses and brand affinity. Guiding attendees to an online store ensures they will leave the event with a product that won't become redundant, while also showcasing your company's product offerings.

If your company or client opts to spend more on giveaways, then by all means choose high quality swag. Some conferences advertise their attendee give-aways and make event gifts an integral part of their sponsor integration. Take TED for example: The gift bag is a part of the experience that many repeat-attendees look forward to, and even chatter about on social media. One year, TED gave attendees sleek suitcases that went for $450 retail, and a $150 gift certificate to use in a room dedicated to the TED "gift experience" On the second-floor of the cavernous Vancouver Convention Center, one meeting room is specifically designated to house everything from books signed by conference speakers, to bespoke artisan jewelry. For TED's 1,800 affluent attendees—who pay anywhere from $8,500 to $17,000 to access the conference—serving up impressive gifts that haven't already landed in their online shopping cart is no small feat. Since the gift experience has become such a beloved part of TED, the conference actually part-nered with Rachel Shechtman, founder and CEO of the retailer Story, to design the TED gifting experi-

ence. Shechtman's unique Manhattan store features new or surprising items every four to eight weeks, and she's channeled this ability to pick the most unique consumer products for TED attendees. The result? As one attendee tweeted, the gift experience garners the very same bustle and attention from the first moments of the conference as Black Friday does with excited shoppers. In fact, TED swag is so popular that every year a popup FedEx counter is arranged next to the swag room so that attendees can have everything shipped directly home. TED exemplifies an important point: When strategizing the entirety of your event, always consider the complete user journey from start to finish. Remember this: The customer journey isn't complete until your attendees finish their travel route back to their homes.

I've used swag to achieve various goals in creative ways over the years and will end with one example I developed for an exclusive event for my company's top C-Level customers and prospects. The first version of the Android watch had just launched, and we wanted to get the new gadget onto the wrists of our attendees. Rather than just give them away, we used them as a mechanism to increase networking and flow at our evening event. Our evening event took place at The Battery, an exclusive club in San Francisco, within three separate rooms: the terrace, the living room and the penthouse. Our challenge was creating an incentive for guests to flow throughout each unique space and not end up in one room by default for the duration of the evening. Before guests

arrived to The Battery, they received a vintage key with a number on it and were told that they had to figure out how to use the key throughout the evening. We had sourced three large apothecary cabinets, labeled each drawer with a number, and placed one cabinet in each of the three rooms. Once a few guests figured out that the keys might correspond to the numbers on the cabinet drawers, it created a buzz and guests began moving throughout the spaces to find the cabinets, unlocking the correct one to reveal their new Android watch. It was a creative way to break the ice between our guests while delivering our product to them in a way I'm sure they'd never experienced and wouldn't soon forget.

When you narrow your focus and excel in a specific area, you stand out among others in a crowded industry.

-Gianna

Establishing Your Niche: From Cabernet to Contracts

Have you ever been in a restaurant where everything was just *so-so*? For instance, the salmon was fine; what it lacked in flavor it made up in portion size, but no single dish was remembered or praised during the experience? If you found yourself nodding, you also likely have been to restaurants that have a short, tight menu with perhaps fewer dishes that are all exceptional. Well, just as in the culinary world, specialization will bolster your resume as a planner. There are benefits to being a "jack of all trades," but when you narrow your focus and spend more time excelling in a specific area, your resume will stand out among others when a specific role is needed. Many successful event planners have crafted their expertise by developing prowess in one area within the event planning field. Whether you've chosen a niche or not, don't worry; becoming an expert doesn't happen overnight, and many professionals don't begin specializing until well into their careers. It doesn't matter whether you start

specializing today or a year from now, so long as you stick with your chosen niche long enough to earn your expert credibility.

Defining a niche doesn't have to be a preliminary choice when you're first starting out as an event planner, and working at a company that has a specialty can help you hone unique skills without making a firm commitment. For example, destination management companies, or DMCs, are one example of specialization within the spectrum of event planning agencies. DMCs specialize in a particular locale. They train their employees so that they are experts on all things pertaining to that geographical location, from venue selection, to caterers, and other vendors. Beginning a career in event planning at a DMC has the advantage of providing exposure to many elements of event planning, which can prove useful when deciding which particular specialty to later pursue in depth. I happened to get my start at a DMC in San Francisco. Working on the product development team helped me build a solid planning foundation while learning all of the best venues and vendors in my new city. This proved valuable to me moving forward, even though I didn't end up working at a DMC for very long. Whether you decide to become an expert on contracts, permitting, food and beverage, or creative ways to apply technology to events, consider your choice similar to picking a life partner. You wouldn't marry in a heartbeat, and your niche is going to last the length of your career. Take some time to explore different areas of the planning industry and find an

area that you'll not only excel at, but which piques your interest. Your specialty will grow and continue to develop with you, but you might also find your passions evolving. If this becomes the case, there is no harm in changing areas of expertise.

Within the two primary markets for event planning, social and corporate, there are hundreds of pain points that beg for expertise. Whether you're a social or corporate planner, every entity is looking for new ways to connect with their demographic in a meaningful and memorable way. The need for planners is growing—the number of events hosted annually reached 1.93 million in 2018, almost doubling the number that was recorded back in 2000. According to the database company Statista, 73% of the events held in 2018 featured new technology that required planners with *special expertise*. Companies are using technologies like facial recognition, artificial intelligence, live-streaming, social media walls, and more to engage with their audiences and bolster their ROI. Developing expert knowledge of these newer technologies and integrating them into your event's infrastructure is a great way to stay ahead of the planning curve. Think about finding a niche that you enjoy *and* will put your CV in high demand.

It's also important to think about the market you're located in. What pain points have you encountered in your local industry? Or, what specific problem do customers experience time and time again within your agency's client base? Take out a sheet of paper and jot down as many problems as you can think of.

This is where you'll find the most opportunity to stand out.

Like any problem, customer pain points are as diverse and varied as your prospective customers themselves, and over time you will develop a knack for understanding where you can best offer counsel. One woman freelancing for an agency I worked with instantly caught the attention of my team when she vocalized her permitting expertise in the San Francisco Bay Area. Staying true to her market, she realized she would become invaluable if she focused on something that was cumbersome to navigate for companies in the San Francisco Bay Area, but necessary for the success of any event that required a permit or street closure. Event organizers must be compliant with a myriad of rules in order to properly obtain the right permits for events in San Francisco, as well as know who to engage to broker approvals. This requires relationship building, something that came naturally to her *and* that she enjoyed, so she capitalized on that personality trait and developed a niche that has made her invaluable. Pain points might not always be the most riveting path to pursue, but offering relief to clients will make you priceless, which could pay off for your career in the long run.

I have always committed myself to a tight schedule, and can personally attest that I am just as efficient when I have more on my plate than when I have a lighter schedule. Tight days actually enrich my life and keep me sharp and passionate about my work. Keeping focused has allowed me to specialize in

several areas over my career. Teammates now turn to me when they want a stand-out wine list, need help dissecting a contract, or choosing an interior color and materiality scheme. You'll learn about my contract and interior design tips shortly, but first let's shift gears slightly and tap into something everyone can appreciate: the allure of a beautiful bottle of wine!

From an early age, I fell in love with California's northern wine country, Sonoma and Napa Valley. By the time I could finally enjoy the bounty of the wineries, I had already decided the rolling hills and cool, starry evenings made wine country a magical place. When I was able to sip wine while overlooking such natural beauty, I became so enraptured with the rarefied region, I knew it would somehow play a larger role in my life.

From the farm-to-table restaurants to the beautiful vineyards—wine country gives off a vibe that both enchants and endures. For me, Napa Valley is a place where spring's touch turns entire hillsides emerald, and time stands still as evenings stretch into wonderful memories. It has become the place I go with my husband to step away from the bustle of San Francisco and return to a level of peace only nature's arena can provide.

It's also the place that showed me the power that wine has over us. I can still remember so clearly evenings when special vintage bottles were enjoyed, as if I'm looking at a picture. I have long held the belief that wine does something to us all that's worth noting.

Since wine is served at most evening events and is a subjective art form that people truly bond over, I decided to develop an expertise on wine and Napa's most revered venues and wineries. It soon became my passion and also a channel for me to provide service to others. I loved my area of expertise and the research involved: wine tastings, fun readings, excursions with friends, and I knew my choice would keep its relevance.

When I decided to get my sommelier's certification at the Court of Master Sommeliers, I had a distinct goal in mind. Not only did I want to become an expert for my team at work, but I wanted to be a knowledgeable host to friends and family, and maybe future Napa Valley visitors. Alexander Fleming, the Scottish bacteriologist credited with discovering penicillin, once said, "Penicillin cures, but wine makes people happy." I find this much to be true whether I'm with executives or childhood friends. Becoming a sommelier meant holding the key to inciting just the right mood, whether that be light, intense, or elegant. When I practiced blind-tasting, I took careful notes on every sip and used deduction to guess each varietal based on the history and characteristics of the rieslings, chardonnays, and pinot noirs I'd studied. A sommelier's job is to make choosing great wine less intimidating for people and more of an approachable process. When studying, I imagined a winemaker agonizing over important decisions: whether or not to use new oak, or create a more terroir driven wine, free from enhancements. Maybe she agonized over how

long to leave the skins in contact with the juice, to create just the right amount of structure but not an overly tannic wine. Maybe she wanted to produce a wine that was going to please oenophiles and be more esoteric, or be approachable with a more general consumer base. Thinking through hypothetical situations was a game, but also a way to remember the extensive variety of decisions needed to make the wine I loved.

I quickly learned to evaluate a unique wine without measuring it up against my own preferences. Now, when I speak from an objective standpoint on the wines being served, no matter who my audience is, they listen. As for the relevance of my expertise in the future—we are living in an age that pushes us further and further away from the outdoors. When we crave the earth deep inside a city venue, wine provides an easy way to return to our natural roots. We can taste the strong tie to the soil that feeds us. It comes with flavors of smoke, earth, melon, vanilla, and even grass. However, with the unbelievable variety that exists today, choosing the right vineyards and bottles to evoke the tastes you're looking for inspiration takes more than a hopeful guess. When I select different wine lists for varying demographics and styles of events, I calculate just how each will contribute to the ambiance and mood I'm planning to achieve my goals. The true beauty of wine rests in the fact that no style satisfies all tastes. When making your selections, it's important to understand your demographic and the setting.

When serving wine, there are general rules to follow: Traditionally, wines are served in order of body (white wines have a lighter body than red), and dry wines should come before sweeter blends. However, the food served at the event is the real determining factor of which wines are served, and when. The most important thing to remember is that wine's main duty is to enhance your menu. The wrong pairing can actually detract from the flavors you're trying to showcase. For example, never pair a red wine with oysters—it will make the wine taste salty, and the oysters taste foul.

As a general rule, when asked to select wines to pair with a meal at an event, I recommend reviewing the tentative food menu first. From there, you can choose your wine list based on how it will complement the taste of the food. A good pre-dinner choice to serve with hors d'oeuvres is sparkling wine, and an aperitif stimulates the appetite. The bubbles in champagne pair well with salty things, so pass this in flutes with savory appetizers.

When serving wine at corporate events, I also take into consideration the style of event, budget, demographic I'm serving, and any stakeholder preferences. When planning events in California, I try to source local wines as often as possible. California has so many amazing wine regions, and this bodes well for sustainable practices and also celebrating the local sense of place with attendees. However, if I know the attendees are a C-Level international group, I'll know that many of them will feel more comfortable with an

internationally-sourced wine list, so I'll be sure to pull in a Bordeaux, Champagne, Barolo, and perhaps a Chateauneuf du pape. If I need to source quality wines on a tight budget, I look for alternative varietals or regions that are similar to more expensive wines. For example, rather than sourcing a Cabernet from Napa, I'll source a Malbec from Argentina. Both are full-bodied, tannic, and layered, but the Malbec is much more cost-effective since growing grapes in Argentina is far less costly than the cost per acre to grow grapes in Napa, and this translates to lower prices. I became a sommelier because of my curiosity and passion for wine and found a way to differentiate myself and enhance my events with the power of this strangely unifying beverage.

I've always believed that leadership requires elements of good management, but it also requires that you inspire, build durable trust, and remain accountable for anything that could possibly go wrong. In chess, there's a saying that a good player is always lucky. Likewise, in event planning, the more expertise we develop, the more successful our events become. In my career, I've applied this tenet to the area of contract negotiation techniques. Mastering this area has ultimately saved millions of dollars *and* headaches.

When I started to understand how to negotiate with hotels and venues, I learned that defining parameters between a company and client is the very first step in every budding exchange, and it's worth it to understand how the management of venues and

hotels operate. The negotiation between planners and high profile properties is delicate, but it needs to be set in stone so that there is no room for confusion. The back and forth pattern of negotiation isn't dissimilar to the way partners move when first learning the waltz: Both parties might try to move forward with their most favorable outcome, and then step back just as quickly to allow room for a counter offer. I've found that securing your company the best deals with hotels comes down to knowledge and experience. You can ultimately orchestrate a synchrony between both parties, but first you must understand what is the desired outcome for your company, and a satisfying payment and terms for the venue in question. If you do so, the result will be sweet and comes in the form of attractive rates, sound clauses, and of course, upgraded rooms and amenities for your attendees.

Since every hotel company is unique, each contract will be, too. When it comes to hotel contracts (and venue contracts in general), there will always be a number of clauses concerning amenities and other areas of value to your company and attendees. More often than not, hotels won't include anything in regards to specific amenities in the beginning but will oblige if you ask for them. There's a general framework that should be followed each time a contract is drafted, and I still refer to my notes each time I review a contract to make sure it accounts for all key clauses. Never assume a contract is standard, since doing so could mean the difference between a successful or disappointing stay for your guests.

When it comes to booking hotels, always secure a written statement that ensures your agreed-upon group rate during peak program dates is the lowest possible rate. This means that any rates that are published on a hotel internet website or third party site after the contract is signed must not be lower than the rate you negotiated for your group. Equally critical is a clause that states that the hotel cannot release any guaranteed rooms without your written consent. This means that even though there is a cut-off date when rooms must be assigned or released, the hotel cannot sell the empty rooms without your approval. You'll find that this matters for a variety of reasons. For instance, if you're in charge of planning a trade show or conference, you'll likely have attendees signing up close to the day of the event. If the hotel releases rooms without your knowledge, your attendees might wind up without any available accommodation. Think about large events like South by Southwest and the sheer mass of people that wish to attend. If your blocked-off rooms are released close to the first day of the conference, any last minute signups likely won't have a fighting chance at finding rooms in the whole of Austin. In one presentation, I outlined a trick to use instead—provide the hotel with dummy names to ensure that rooms aren't released if you still haven't heard from any on-the-fence VIPs (I use my family members so they're easy to find and replace). As last-minute guests register and require hotel rooms, I go in and swap-out the dummy names for actual guests. This way, I'm never in a lurch, and

the hotels can rest assured that I'll cover the rooms contracted.

Another important component to internalize is the attrition clause. An attrition clause is a commitment to pay for a specific number of rooms, even if you no longer need them. Most attrition clauses are stated in percentages, so a 90% attrition clause means that if you hold 100 rooms, you are committed to pay for at least 90 of their rooms, whether you fill them or not. Some hotels are known to have a 100% attrition clause, so you must fill all of the rooms you've contracted, but this is all negotiable and this percentage can fall to as low as 70%, allowing you more flexibility if you're uncertain how many attendees will end up reserving a room. In order for the hotel to guarantee a group a certain number of rooms, they must remove them from their inventory for the requested dates. It *does* make sense to hold a company liable, and most hotels will require that at least 75% of the total contracted room be paid for once committed by the company. After all, a wavering head count means less business for the hotel, and hotels are one of an event planner's strongest partners, so we want to do what we can to protect their business.

However, sometimes, attrition charges are much higher than necessary and you have to step in and firmly negotiate. Here are a few ways I find useful in working with top hotels while not overpaying for top accommodations. One trick is moving off-site events and meals to the hotel to generate another stream of

revenue. I always recommend thinking about paying hotel attrition penalties in the hypothetical form. Guessing how many attendees will cancel is similar to playing a game of roulette. Instead of toying with a risky game of trying to determine the right number of rooms to book, I budget conservatively and allocate a higher number of rooms than I may need and make sure to hold enough budget to cover any attrition penalties if needed. However, even if you're faced with paying attrition penalties, you can ask a hotel for the occupancy report. This way, you will know whether the hotel ended up in a better financial position or not, even if your contract was under-performed. If all of your unused rooms were resold each night, the hotel cannot legally charge you for attrition since they would be getting double the value of the room at your company's expense.

Finally, a "no walk" clause should always be included in your contract since they protect against extremely irksome situations. Imagine a VIP guest arrives at the hotel after a long flight, only to learn that his or her reservation won't be honored. Hotels play a game of chance when it comes to obtaining full occupancy at their properties, and sometimes they end up overbooked (just like airlines). The hotel then has to "walk" some guests to a different property. Sometimes they even go so far as to relocate an entire event to accommodate another company that is willing to pay more for the space. When faced with the prospect of walking, whether it affects an individual or the whole group, a tight contract will save

the day. Knowing to add in the no-walk clause means your group won't end up bumped to another property.

When designing the no-walk clause in your agreements, outline very specifically what it will mean for the hotel if the outlined obligations are not met. Make it economically difficult for the property to push your business out, by stating that alternate accommodations must be supplied at a comparable hotel, at no charge to your company. If you booked a five-star hotel, your guests must be relocated to a five-star hotel. Complimentary roundtrip transfers for each guest must be offered, and comped meals and even spa packages, too. Of course, your agency's legal counsel will likely recommend a longer list, but here's the gist of what should be comped by the hotel, should they walk your party:

- All relocation costs
- All incidental and consequential damages
- Third-party vendor costs and fees, which might include airline ticket change and/or cancellation fees
- All differential costs between what would be paid vs. what the new costs might be

Perhaps you haven't had the chance to experience your first major event cancellation, good for you! It's likely not if, but when, and I recommend mentally preparing for this day now. Sometimes the decision comes from upper management, sometimes from a natural disaster, and the list goes on. It *does* happen,

and delineating the obligations of the hotel in the face of an event cancellation within a contract is paramount. You will always legally have the right to revoke your agreement. Should the hotel fail to comply with any of the terms negotiated in your contract, your cancellation clause could prevent a long legal battle. An event I had been working on for a small city's worth of people was canceled not too long ago, and the whole experience left me thankful for the airtight cancellation clauses I had negotiated with venues and hotels. Without it, hundreds of thousands of dollars would have been lost.

Finally, check out the list of complimentary amenities. Hotels still list "free local calls" as one of the perks for guests, which might have worked thirty years ago, but certainly doesn't benefit us today. Ask the hotel to exchange this line item for something that aids guests, like complimentary corkage service. "Freebies" are a part of a hotel's draw, but they're not set in stone. List out the amenities you believe could be exchanged easily enough for better options, (airport transfers, complementary health club passes, room upgrades, high speed wifi) and work with the hotel to pave out the perfect stay for your guests.

By now, I think you get the picture. Four words should always have a place within a planner's handbook: *Get it in writing*. Promises made during the course of a conversation with hotel/venue management can be forgotten easily enough; we're all human after all. Knowing how to negotiate the best contracts is an important step on the road to success, and

whether you choose this as your niche or not, I hope you dig deeper into this part of the planning process. You can't predict armageddon, but when things go awry, it's reassuring to let your stakeholders know that you anticipated the "worst case scenario" months ago —and letting everyone know that the company is legally protected. I could write an entire book on this (and perhaps I will some day!), so if you want to learn more, find a mentor, take an online class, or meet with hotels and get to know their side of the business.

The ambiance of a venue is the base for your event and influences the way attendees absorb information.

.-Gianna

6

Finding the Perfect Venue, and Beyond

A sense of place is one of the most basic but important aspects of event planning. Think about it: would you ever plan a wedding at a sewage plant? A festival at a financial institution? How about a child's birthday party at a scrap metal yard? Ok, these are some ridiculous examples to get your attention, but they illustrate an important point: A good venue supports an event, a great venue enhances it, but a poor venue detracts and distracts attendees from the experience. You know your unique role on the team, and how to approach an RFP, a contract, a wine list, and more—now it's time to dissect the deciding factors of venue selection.

Before you even begin your search, you should identify key criteria that serve as a basis for your future venue evaluations. Down the road, this rubric should be referenced when giving recommendations to clients or agency members. When it comes to investing a company's resources, venue choices should

be grounded in substantial qualities rather than superficial ones.

Every event requires a specific set of attributes from a venue, but there are a few things that I've found common to most events. One of these is proximity to travel hubs. If ease of access for your attendees ranks high on your priority list, the closer your venue is to lines of major transportation, the better. You can guess as much, but this is due to the time it will take attendees to get to your event venue. If you find the perfect venue, but it's a two hour drive from the nearest airport, this may be logistically prohibitive to commit to for attendees on the fence. The same goes for speakers and executives with ultra-compressed schedules. A long commute to a venue can prove too challenging, and they might end up passing on your event altogether.

Cost is another consideration, which makes choosing a central location for a large conference a wise choice. The least we can do as planners to reduce both costs and emissions is to choose venues and hotels within fifteen miles from airports (or major train lines if your event skews towards a local crowd) and try to mitigate lengthy travel for the bulk of our attendees.

Going a step further, finding venues with close proximity to a city's unique and seasonal attractions will improve your guests' overall experience. Mentioning nearby attractions in a well-organized email or directly on an event app can do wonders for increasing the enthusiasm surrounding a certain area.

This is especially important if you're hosting an event that spans two to three days. Consider any direct links hotels have to the area's downtown center, and if the hotel sits slightly removed from the center, I recommend offering discounted ride-share trips. For example, Uber for Business launched a world-class customer transportation solution called Uber Central. With Uber Central, organizations can provide on-demand transportation for their guests. Uber Central has one especially noteworthy feature: Customers aren't required to have an Uber account to receive a ride. If you're like me, you can't imagine life without your ride-shares, but as of December, 2018, only 52% of Americans had registered accounts with Uber or Lyft. Setting up rideshare partnerships is easy to do and a great way to show your consumer base how customer-centric your brand is. Overall, it's a win-win.

On the other hand, if you're planning a more intimate retreat, I recommend opting for a more remote location, perhaps in the mountains or the country. There are fewer distractions outside major cities, and studies have shown that taking a corporate team out of their natural work environment puts people in a more collaborative, open mindset. It also deters people from heading out to answer "urgent" phone calls or emails that they might attend to had they been in a setting that resembled their own fast-paced office space. Furthermore, out in the country, it's easier to think creatively since there's less distraction to hinder our ideation. Choosing a venue near nature might

inspire group hikes and other organic forms of networking. After all, golf courses and tennis courts aren't merely avenues for sports, but also channels for bonding. As Henry David Thoreau once famously quoted, "In the woods, all societal norms and influences are far away," which bodes well for any corporate team hoping to connect in a few days time.

Once you've found an appropriately located venue, you'll have to give the inside a thorough evaluation through both an objective and subjective lens. The ambiance of a venue serves as the base for your event and can influence the way attendees absorb information. For this reason, the power of a well-designed setting should never be underestimated. One of my favorite examples illustrating this point comes from the arts, when Ernest Hemingway vocalized an intellectual debt to post-impressionist painter Paul Cézanne. Hemingway credited Cézanne's paintings with helping him reorganize the structural necessities of the modern short story form. One of Hemingway's beloved short story classics, "Big Two-Hearted River," came after he positioned a number of Cézanne's paintings in his studio. While these artists are long gone, the point remains: The right aesthetics are more than visually pleasing, they hold a unique power over us.

Like the late Cézanne, we can truly inspire others with the unique settings we create, particularly when it comes to planning more intimate events with a smaller audience. Big crowds call for an expansive space, but there tends to be more flexibility with

factors like location and interior aesthetics when working with groups of 400 or fewer. Executive gatherings, for instance, deserve a compelling setting since they serve as a cornerstone for maintaining company connectivity and generally cater to a demographic with refined tastes. We might be living in the era of the fifteen-minute coffee meeting, but an opportunity to linger over a delicious meal can lead to longer conversations that can deepen relationships and positively impact business. If you have the opportunity to plan an intimate experience for a small group, such as an executive dinner, I recommend choosing the most memorable venue possible; it creates the expectation that this will be a high-quality event and a worthwhile time commitment.

I still remember one executive dinner I planned early in my career, at one of Napa Valley's most exquisite wineries, HALL Rutherford. We didn't just plan a seated dinner, but rather a progressive event that would kindle camaraderie, break down barriers, and celebrate the company's success over the past year. After being welcomed with light appetizers and sparkling wine in Hall's modern art gallery, guests were escorted down to the barrel room where they attempted to concoct the best red wine blend in a friendly competition. After the winners were announced, everyone sat down to enjoy a delicious four-course meal served in the iconic Rutherford Chandelier Room. Under Donald Lipski's magnificent "Chilean Red" chandelier, guests converged on opinions, imparted insights, laughed, and let tension fade.

The chandelier, adorned with 1,500 Swarovski crystals, glinted against the crystal glasses holding the luxurious Hall wines. The expansive cherry wood table, with illuminated onyx, reflected the chandelier's beauty. We all have an innate craving to feel special, and that night, ten feet below reality in a rarefied cave room that had hosted the likes of Bill Clinton and Barack Obama, a company's executives forgot their daily burdens and connected in an experience like no other.

Remarkable as this venue was, Hall Rutherford isn't suited for most events (although this is part of its draw). However, the right ambiance can always be created if a venue doesn't have the perfect brio from the start. There's always a way to work around or even *cover up* existing decor that doesn't match your event aesthetic. For instance, my team has turned ornate ballrooms into modern, sleek arenas suited for a more technical event. Chandeliers can be covered with custom, sheer cylinders, and loud carpet colors can be muted with coverings, too. When walking through a venue, vocalize your questions and concerns before ruling a venue out simply for aesthetic unpleasantries. Ask if you can remove furniture, and paintings, too. Fine art can be difficult to store, but there are proper steps that can be taken well in advance to change a venue's wall displays. More likely than not, the management will accommodate requests and supply instructions with how to go about storing artwork and furniture.

With all this being said, there comes a point when

a venue layout simply won't work. For this reason, chronicling staple requirements for regularly hosted events will help you quickly decided whether a venue works. Let's quickly run through criteria for one of the most common event types, the mid-sized conference (5,000-8,000 attendees). On your venue hunt, look for spaces with:

1. At least one main conference room (be sure to allocate ⅓ of the space for staging and a backstage area for production purposes)
2. One or more room for meal times
3. An area for registration and hospitality
4. Breakout rooms
5. Additional meeting rooms
6. Production office and storage space
7. Executive meeting rooms
8. Evening Event space (unless hosting off property)

Now, within each area, consider the logistics of the space:

- Do you want people seated around tables or in a classroom-style seating arrangement? (This will take up more than double the space than theater style seating will, but may be necessary given the purpose of your event.)

- What orientation should the stage be in the room?
- Do you have an idea of which breakout session will be most popular? How will you map breakouts to specific rooms?
- Will all meals take place in the same location, or do you need a separate space for breakfast / snack breaks, lunch, and dinner?
- For meal space, do all guests need to be seated to eat at the same time?

When scoping out the various areas within a venue, one challenging component to predict is proper allocation for breakout sessions. It's nice to reach out to attendees early in the communication process with a short survey to ascertain which topics they're most interested in. Even a few completed surveys can indicate which topics may have the most interest and therefore, require a larger room. If it seems like one session is overwhelmingly popular, you can always consider offering a repeat the topic in another session.

When accommodating large numbers of people for breakout sessions, try to remain as flexible as possible when assigning sessions to specific rooms. It's also important to determine the maximum capacity of each breakout room space, with built in attrition in case some people decide last minute not to attend. It's best to allow people to sign up for breakouts in advance. This way, you can "cap" the number of

people who sign up once you hit your target number for capacity, and manage a waitlist online. By having an onsite waitlist line, you not only offer attendees who didn't secure a spot a chance to get in, but you also fill any attrition you may have. This is why it's important for venue planners to get acquainted with the content, mobile app (if you have one), and web development for an event, since every component of the overarching strategy connects to an audience throughout various parts of the event.

At some point, you might find yourself opting for a venue that allows creative liberty; a blank canvas. If you do source a completely open venue with minimal infrastructure, such as a warehouse or empty pier building, you will have the benefit of getting to build out the interior of the venue into the exact configuration needed for your event, while exploring unique scenic elements. This is generally a more costly route than when opting for a venue with built-in walls, a kitchen, meeting rooms, and infrastructure. Not only will you have to create all of your own scenic (floors, walls, meeting rooms, stage) but the labor costs to implement these elements quickly adds up. When you tack on the extra hours you'll need to rent the venue for load-in and out, your budget can add up quickly, so be sure to consider all costs associated with going this route.

Creative ambition aside, there will be times when you need to completely change a venue to accommodate a company request. One year, for our Global Women's Leadership Summit, we couldn't find a

venue close enough to the company's headquarters that could accommodate a group of 500 for keynote, meals, and breakouts. Surprisingly, despite the number of major companies headquartered in Mountain View, there's a scarcity of venue space for events larger than 200 guests. So we all tapped into our creative reserves, and ended up securing a volleyball facility for the event. Interior aesthetics aside, the space checked off a number of boxes: ample space, high ceilings, proximity to our headquarters, a suitable number of restrooms, and affordable venue rental.

A substantial budget was allocated to account for the many hours it would take to develop a floor plan, add infrastructure, and build out the interior, but the low venue-rental helped mitigate some of the added costs. Once all the volleyball nets were cleared out, we built bespoke walls, attractive flooring, and ultimately created a lovely community hub, keynote space, and even a mother's room, (an important and thoughtful detail given the demographic). When the day of the event arrived, we ended up with a beautiful venue in a palette of greens and teal with copper and wood accents that evoked an overwhelmingly positive response from our female leaders. The icing on the whole cake came in the form of shocked faces, when members of the team casually mentioned we were in a sports facility. Reactions ranged from mild surprise to pure shock that we had been able to render the gym completely indistinguishable!

. . .

That old cliché, *Moderation in all things,* certainly applies to a venue's acoustics. Have you ever attended an event that was so loud that it was hard to hear others, causing you to strain your ears and lose your voice, all in the same hour? The way that sounds travels through a venue is easily detectable if you know what to look for. A low ceiling will make a venue seem more cozy, but will also trap sound like smoke in a window-less closet. Alternatively, high ceilings will result in echoes, or what architects refer to as reverberation. The materials used in a venue will either reflect or absorb sound, so be mindful of what the floors, walls, and ceilings are made of. On your site visit, take note of any unwanted sound that's immediately detectable; is the air conditioning noisy? Does the sound of neighboring construction or honking horns filter through the walls? Are meeting rooms soundproof?

Now, go a step further, and ask to turn off the lights. Look for areas where light filters through. An area that light penetrates may also be prone to unwanted sound waves, too. This doesn't render a venue useless, but you'll want to think through ways of mitigating sound and light interference. You can always control noisy HVAC systems by pre-cooling a space and leaving all systems off during a keynote, but this really comes down to an executive decision regarding the room capacity, and the season. You can always bring in carpeting and wall tapestries to absorb some of the "aliveness" in a space, but if your dark-ened room still allows sound and light to bleed in

where you don't want it, you may try to negotiate the rate down to account for these grievances.

Last, but certainly not least, you'll find most venues have a Food & Beverage Minimum, which can easily become a costly part of booking a great venue. Simply put, a food and beverage minimum is a specific dollar amount in "F&B" that you, the client, must meet in a selected space, and if you don't, you're obligated to pay the difference. In order to combat a particularly high F&B minimum, I recommend requesting records from previous events in order to make sure that all have been in line with the venue's required minimum. If you're planning on holding any meals off-property, consider asking the venue if you can use the venue's kitchen and staff in lieu of hiring a caterer to hit the minimum. In some instances where I've been forced to hit high F&B minimums on smaller, high-end events, I've asked if I could use part of the budget to purchase nice bottles of wine to give to the speakers or event staff as gifts. There's no harm in getting creative, and more often than not, the venue manager will acquiesce to reasonable requests.

Conversely, if you estimate a much higher F&B spend than what the venue requires, it means you're now sitting in a power seat. Negotiate free venue rental in exchange for a high guaranteed F&B spend, or other services or perks (i.e. upgrade Wi-Fi or an extra load-in day). I always make sure my catering manager gives me a report at the end of every day. Questions like, *How much food was left over from the event?* and *How much coffee did attendees drink?* will become a

baseline for future years. Yes, you've likely learned this early on, but it's also easy to forget to account for these stats. As mundane as docking cups of coffee is, it's still data, and using coffee metrics in the future will help prevent waste and help your company's bottom line.

Since most F&B minimums do not include tax and service charges, always be sure to ask your venue what these percentages are. Most importantly, figure out whether the venue applies tax and/or service fees to the venue rental as well. Taxes are based on state sales tax, but service charges (and gratuity—if the venue wants to double hit you with labor costs) can fluctuate and add an additional 25-35% to your total cost. These extra charges can quickly rack up and add thousands of dollars to your final invoice, so consider yourself warned.

Many hotel properties and event venues have concrete restrictions, so I always make a special note of any hotel brand that goes above and beyond to accommodate extraordinary requests. The Ritz Carlton is a premiere example of one such company.

We hosted the second annual APF at the Ritz Carlton Half Moon Bay property, and I'll never forget the way their management team worked with me to accommodate our many unique requests. From the removal of artwork on walls, to the installation of a decorative tent for meals above the parking garage— the Ritz Carlton staff stayed attentive to the factors that were critical to the event's success. For our product showcase area, we wanted to insert an

autonomous car inside the hotel's foyer, no easy feat, indeed. Our first plan was rejected, but we later found a solution, and were allowed to proceed. I've found that asking the question, *Why not?* creates opportunity for solutions, and I recommend that you try this if you really want to implement an idea. Our Ritz Carlton sales representative told us that gasoline wasn't permitted inside the venue, so we said, *Fair enough— we'll drain the car,* and we did! We were able to complete our vision and provide a stunning surprise and demo for our guests, just steps outside the keynote doors. Tap into your creative mindset, and I guarantee there's always a work-around in some shape or form. And don't stop asking questions until you come to a solution.

After pausing for selfies with the car, our guests enjoyed breathtaking views overlooking the Pacific Coast. During breaks from sessions, a number of people enjoyed the sweeping golf course surrounding the property for recreational reprieve. Meals consisted of fresh, wholesome, local, and utterly delicious food. I've always found that both the properties and staff associated with the Ritz Carlton brand truly come second to none.

I was honored to be invited to sit on the Ritz Carlton Tech Advisory Board a few years back. I had always assumed board seats were reserved for those above forty, so I was completely surprised when asked to join, and I graciously accepted. For any company that you interact with at scale, there is likely a board you can participate on, and I encourage you to

inquire about positions if you're interested in contributing to industry improvements and making new connections.

On my end, since I conducted a large number of RFPs for many of the Ritz Carlton locations and had been privy to many detailed assessments, it made sense that I help their board by providing feedback as one of their key accounts. Soon after I joined, I was invited to attend a three-day Advisory Board event in London, at one of their brand new Edition Hotels. The Edition branch was at the time a recently launched collection of Ritz hotels that are luxurious, yet slightly more modern and edgy than the traditional Ritz Carlton brand. Through this experience, I noticed firsthand how certain brands complement each other. Virgin Atlantic flew all of the attendees to London, seating everyone in uniquely innovative upper class offerings, which paved the way to an equally singular experience inside the Edition Hotel. When you join a board, it's likely that your selection has something to do with your unique background or skill-set, but it affords you the opportunity to quickly pick up on other things outside your expertise. Learning the lengths a brand goes to offer premiere customer service (both on land *and* in air), I found my perspective enhanced in regards to the way major companies work together to provide a comprehensive journey to their shared target audience.

Okay, now it's *your* turn to step up and join a board or organization. Find something positive about what you love within the planning industry and turn

this nugget into a unique introduction you can use at a moment's notice. For instance, rather than state your job title after the standard, *What do you do?* question, memorize something memorable to make an impact in your new contact's mind. Instead of quipping, *I plan events*, try, "I inspire the next generation of leaders and managers through memorable experiences," (or something like that). You can always take your hunt for networking to social media audiences, too, and find possible introductions to opportunities through Linkedin and Facebook groups. I've also made connections while on vacation, out in restaurants, on airplanes, or while enjoying a winery. Averting your attention from the safety of your phone screen just might earn you a valuable new connection, pave the path for a partnership, or inspire you to indulge in an intriguing new opportunity—so eyes up, and keep an open mind!

Interactive elements turn passive guests into active participants.

-Gianna

Creating a Memorable Environment

You've just received the brief. Now, it is time to answer the question: *What will it take to reach my attendees on an impactful level?* You sit down and brainstorm a unifying theme for the overall communication of your event. Now it's time to choose a venue and integrate your theme into parts of the interior design and experience. Let's dig into the components of a well-developed theme and design elements that will help elevate a venue beyond the ordinary.

Your theme sets the tone for your entire event and serves as the anchor which connects all of the content. A theme should reflect the objectives and purpose of an event and remain consistent with company messaging. Themes are used more frequently for social events, which lack company branding and products to help in creating a cohesive narrative to tie everything together. However, themes can be effective for corporate functions on occasion, and I'll outline

examples of how a theme can be used appropriately for a corporate event.

A common goal of an event theme involves strengthening feelings of community between attendees and this can help foster an inclusive atmosphere. Setting goals comes first, and it's the intelligent questions you ask that will outline the best approach for choosing a theme. When brainstorming a theme, I've found that asking questions that help focus such as, *What do we want attendees to associate with our brand?* and *What emotions do we want attendees to feel at the event?* help shape the groundwork for outlining a big idea that works well in thematic form. Planning a themed event essentially involves aligning many components, so an event feels cohesive to attendees.

One of my favorite examples of a corporate event with a theme happened more than a decade ago. Little compares to the pomp and circumstance around an Initial Public Offering, since it marks a significant stage in the growth of a company. I had the unique opportunity of planning the celebration surrounding EMC's decision (now Dell EMC) to sell 15% of recently acquired software company VMware's shares to the public.

Around the same time as the IPO, VMware employees had moved into a new campus, and the party would commemorate the young company's rapid progression. Diane Greene was the CEO at the time, and her corporate sustainability principles showed in the fabric of the new campus. The new campus was a paradigm of eco-consciousness with

solar panels, reclaimed wood, an organic and sustainable food program, and green appliances. The four buildings each housed a different department, and my team understood the importance of giving each group of employees a special nod. For this reason, our overarching umbrella theme stayed ambiguous enough to plot out an experiential journey, but deliberate in some ways, since we decided to create a unique experience in each building.

The four buildings adopted their own stories, each mini-theme relating to the people who worked within the respective building's walls. I wanted employees to roam the campus and feel inspired to tackle the next challenge in their careers, and this meant creating a narrative that flowed through the various buildings, with enough diversity to spur movement between stations. After all, great memories offer respite, and judging from this bout of driven, persevering people, I could guess that many of them stayed at work long after sundown. What they needed was a one-of-a-kind night to remember. When the night of the grand celebration finally arrived, every last detail had been thought of and executed flawlessly. As my team stepped back to admire our hard work, I thought of a massive city mural. In a way, we were all artists and had contributed to a masterpiece, with our own, thoughtful brush strokes.

In the central courtyard of the campus (or promentory, as they call it), a live band played, so that everyone could hit the dance floor in the crisp, fall air. When the VMware employees wanted a nosh, they

could choose a cuisine from one of the four themed buildings (or try all four, as we hoped). They might find delicious curries in the spice market, local cheeses and charcuterie in wine country, risotto in martini glasses in big city splendor, or hand-painted truffles within a wondrous art-deco menagerie. To our guests, our themed buildings appeared a unique and entertaining experience that led from one discovery to another. We knew we had met our goals of generating excitement for each new campus building and had fostered a way to cross-pollinate employees and campus departments.

I love incorporating interactive elements into my events. This stems from a simple idea: Interactive elements turn passive guests into active participants. This was incorporated into every vignette within the VMware buildings. In the art-deco theme, painters were hired to paint models directly onto towering canvases. In the spice market, rows of seasonings and pita fillings were available to scoop up and bring over to a number of expansive grill stations. The hired chefs would sprinkle and cook whatever had been trotted over, before everyone's eyes. There was a tea bar with over twenty-five types of leaves to choose from and to steep into steaming water. Silk tapestries and bright colors transformed the simple office space into an exotic and mesmerizing haven.

There are a number of stratagems for decorating a large space, and we set up a massive tent *inside* the office, which became the central bar. If you've ever read *One Thousand and One Nights*, you'll recall the scene

where *"The bride walks under a canopy of silk borne by four men."* Our canopy would draw envy from the bride if she had borne witness; the colors were as rich and luxurious as could be! There are a number of companies that supply canopy tents that seem plucked straight from the pages of this classic story, and if you're mulling over a particularly difficult venue to transform, you might consider bringing the outdoors inside, in this way. Utilizing the tent was an easy and effective way to transform the corporate space by muting harsh lighting and shielding sharp edges. Tapestries offer the warmth of a communal space and a tented space simply evokes feelings of connectivity. In our case, the tent also offered a moment of surprise and delight, hanging loosely above the guests, and glowing from candlelight, sparkling lanterns, and hundreds of brightly colored carnations.

In the wine country themed building, rustic plants and luminarias abounded. Leafy vines, wine barrels, and crates brimming with freshly harvested vegetables were perhaps the most convenient of all decorations to fill up the space in an organic and effective way. Live fig trees were set up around this themed building, which seemed to elicit special enthusiasm from the crowd, since people could pluck figs directly from the trees and bring them over to the chefs manning wide grills. Here, guests watched as their chosen figs were seared over an open flame, sprinkled with goat cheese, and drizzled with balsamic vinaigrette. Sunflowers in towering vases added vibrance, and the soft beats of bluegrass music floated over the whole delicious affair.

Can you guess what team sat in this building? It was actually the food services crew, and the "wine country theme" paid homage to the important role this team played daily when crafting healthy meals for VMware employees.

Within the big city splendor theme, one of the most praised features was a fresh oyster bar, where craggy shells from different locations lay on long trays of gleaming ice. A team of professionals stood at attention, quickly shucking countless shells at lightning speed. Strikingly beautiful, but definitively ghost-like, white calla lilies hung from the ceiling in glass obelisk vases. Truffled risotto, mac and cheese, and ceviche were elegantly served from long-stemmed martini glasses. The light was dim with blue up-lighting that complemented the sea of white leather and shiny silver accessories. The whole setting seemed like it could belong in a posh advertisement clipped from Vogue or GQ.

Ultimately, when choosing how to bring a theme to life, it helps to keep in mind why you're decorating the space to begin with. You are trying to highlight possibilities that your attendees might not have considered, or maybe even thought were unattainable. Transforming a corporate environment *can* inspire feelings of awe. I truly believe that inspiration is the most powerful force you can offer as a reward for hard work. It's a major driving force of development and growth, and if I could play a small role in boosting the morale of a talented group of people, my mission was accomplished. As the night wore on, judging from

the laughter and energy around the new VMware campus, I felt a familiar sense of conviction that I had played a role in something much bigger than any one person.

The use of themes worked well for parties such as the VMware IPO celebration, since there weren't any products showcased to help foster dialogue and inter-activity between the company and attendees. For this reason, a theme mades incorporating elements of "surprise and delight" throughout the event feel more natural. When choosing a theme, consider the season for the event since seasonal elements can work as behavioral motivators. According to Kathryn Lively, a professor of sociology at Dartmouth College, our inclination to celebrate seasons boils down to a social construct that started when we were in grade school. Lively told *Huffington Post* that people generally choose a favorite season based on what mattered to them when they were a child. She says, "We're conditioned from a very early age to love certain things more than others. Autumn, for instance, comes with a bunch of exciting things. As children, we come to associate fall with going back to school, shopping, seeing our friends after summer break. It's exciting, for most. We still respond to this pattern that we experienced for eighteen years, in our adult years." Whether you agree with this or not, I think we can all attest to giddy feelings when seeing snow around winter holi-days, or pumpkin-flavored treats come October. No matter what season you're tapping into, when you bring up elements that universally trigger memories,

you'll tap into emotions, so make sure they're the ones you're hoping to evoke.

One year, I decided to embrace an autumnal theme during the first evening of a Tech Executive Summit. I began ideating over special elements of autumn that would evoke feelings of warmth, community, and connectivity within attendees. Autumn reminds me of harvest, bounty, Thanksgiving; coming together at a communal table to break bread and reinforce bonds with people we care about to reflect on the past year and talk about the future. Since the executives would be meeting to discuss strategies for the upcoming year over a two-day period, I knew the welcome-evening's theme should encourage them to leave behind their stress before the following day's busy agenda. With this in mind, I chose the Carmel Valley Ranch as the venue for its picturesque and exclusive location. After touring the charming ranch, I could easily envision a late autumn retreat unfolding under starlit evenings. I had learned that the Ranch's executive chef was heralded for his focus on featuring local seasonal ingredients, and this reinforced my idea of serving up a bountiful autumnal feast on the first night.

When the opening evening of the summit arrived, guests were ushered to an upstairs clubhouse after an outdoor cocktail hour, to break bread under vaulted ceilings. I didn't want to assign seating, but rather enhance cross-pollination by a random seating strategy. I achieved this by passing out envelopes to each guest, which contained the definition of a "famous

number" such as pi (these were tech executives, after all, who loved math and science!). The executives then had to find the table with the number that associated with the definition on their card. It was a fun, playful way to make sure the guests would randomly seat themself, and it built in some friendly conversation as well.

The tables were adorned with an autumnal ombre color palette of florals, plants, and vegetables, creating a visually stunning tablescape. Once guests were seated, the first course of pumpkin soup was ladled into individual pumpkin shells and topped with candied pumpkin seeds. Serving the dish using the entire pumpkin not only embraced the theme, but was a creative and beautiful way to present the first source, setting the stage for what was to come. I decided the meal should be served family style, to play into the communal, less-formal nature of the event. When food is served family-style, attendees have to pass the dishes to each other, sometimes offering to serve each other. This creates a more human connection and bond between the people dining together at a table. There were fire-roasted salmon fillets and racks of lamb drenched in fresh, green chimichurri sauce; herb-crusted beets with pillowy goat cheese, and kabocha squash gnocchi; duck fat confit potatoes and caramelized fennel; and sides that could have served as their own feast collectively. Dishes were cleared after many delighted remarks, and guests shared another course of communal dishes: caramelized fig tartine; gooseberry and blue cheese soufflé with wild

honey gastrique; and lavender infused lemon custard. Each dish complemented the other, and each featured an item harvested from the bounty of the Carmel Valley Ranch.

The cozy campfire is a seasonal element that I knew would make a great addition to the night's fall theme and lend itself well to bonding, so post-feast, the guests were led to an array of glowing chimeneas. Ensconced in the cool night air, everyone relaxed awash in the cozy glow. The scarlet flames from the bellies of the chimeneas made a contrast against the night sky, which had begun to bloom with the first pricks of starlight as guests watched from their long-backed Adirondack chairs. Thick fleece blankets adorned with our company logos were draped nearby to keep shoulders warm if need be, and more than a dozen types of cookies, chocolate squares, and hand-made marshmallows passed between groups. For those who recognized the gooey familiarity of making s'mores, this part of the evening proved an absolute delight. One executive from Japan, who had never roasted a s'more before, pulled me aside to tell me that this would likely be an integral part of every autumn season thereafter back in her country. I smiled, in part because I loved that she had found something new in the folds of the tranquil evening, in part because I, too, believed s'more making is a special experience everyone should experience beyond childhood. When you're sitting at a campfire, you're not checking your emails and thinking about the week's busy schedule ahead. You tend to look right

into the heart of the flames, enjoy those around you, and simply reflect.

Though this theme worked well for the executive retreat, it might not be appropriate for a larger convention. I try to avoid themes if they jeopardize the gravitas of an initiative or water down the importance of a product we're highlighting. In these cases, rather than using an overt theme, I come up with creative ways to introduce a product and make it more relatable or social. This helps people remember it while providing context. For instance, when Google Hangouts had just reached the market, I came up with the idea to hold virtual wine and beer tastings at our Think event evening receptions. This translated into a recurring theme of proving social utility for the product, by way of demonstration. In order to best convey Google Hangout's ability to connect people from all over, the catering team set up a conference room with wine, beer, tasting notes, and snacks. Members from my team and I would tune into a live Hangout with an engaging sommelier, and the entire room would join in a tasting demonstration, carried out by the sommelier hundreds of miles away. Occasionally, the sommelier would call out to a member in the conference room for their opinion on a particular wine, surprising and delighting the guests who weren't expecting such a successful two-way dialogue from the product. Everyone had a great time while experiencing a new product in a fun context.

No matter the quality of a theme or idea, it's really up to the scenic elements and environment of a

venue to cinch thematic elements together. While some planners won't work directly with the interior design aspect of the planning process, taking a deep dive into various parts of the industry can always help you— especially when overseeing different departments.

Personally, I've always found the nuances of design interesting, and perhaps if you haven't fallen in love with another niche, interior design might pique your interest. Growing up, I would tag along with my mom when she went to the large San Francisco Design Center. She was a respected interior designer, and navigated the vast showrooms with elan. As for me, I found the showrooms with their many displays of home furnishings, textiles, and accessories both overwhelming and mesmerizing. That the myriad of styles, shapes, and textures could all be so different, but equally enticing, seemed to demonstrate the boundless possibility design holds. Years after my first walk through the Design Center, I remained fascinated by elements of design and was inspired to take an interior design certification course.

Learning about the technicalities behind interior design helped aid both my professional and personal life in many respects. In the office, I could voice an in-depth observation of a particular venue by bringing up its design attributes. When my husband and I purchased our new home in San Francisco, I could also put my new decorating skills to work, finding pieces that blended with each other, but offered each room a distinctive feel.

Creativity is a muscle and becomes stronger when you use it daily. As you consider how elements work together, your design will evolve to an elevated level. It's not just about picking out the prettiest looking fabrics and colors, but taking into account collaborative practices, economic viability, and people's actual experiences and needs within a space. In this way, design helps you come up with holistic solutions.

Leonardo Da Vinci first developed something we refer to now as "color theory," a key aspect of the design process. For an event, the color theory is the palette and it is one of the most important visual stimuli your guests will experience. In order for a color palette to enhance the overall look and feel of an event, it takes some understanding of how colors work together, and the feelings they evoke. I'm sure you've seen some very strange and disjointed use of color in rooms before, and our aim as planners is to avoid this at all costs. Certain color groups mean different things. Brighter, warm colors, like orange, red, and yellow, tend to energize guests and make them more alert. CNN uses red in their flagship logo to heighten alertness, since the color connects to the site's breaking news content. Conversely, darker cool shades, like blue, green, and purple, tend to relax and offer a greater sense of tranquility, which is why many spa interiors are decked with faint turquoise or sage green.

In my design school, I learned that a "hue" ia a variation of color, lightened by adding white, or muted by the addition of both black and white

together. The combination of tints, tones, and shades support a color family. Other colors on the wheel, though not closely related in hue, complement eachother (such as burnt orange and turquoise). Once your color family has been established, you can use it to pick out décor that complements the color scheme.

Lines are another important aspect of design. On a micro scale, it helps to consider the use of lines in magazines. You can clearly see how they are used to separate content, headlines, and side panels. The technique of dividing space into several sections translates into much bigger areas. We use lines frequently when designing a venue, mainly to draw the guests' view to a specific location. For example, during a Youtube series premiere documenting the Google Lunar XPRIZE's "Moon Shot" program, my team and I made sure to place the lunar rovers (the main focus of the series), further back in the venue. When attendees first walked through the door, they could see the rovers directly, but everyone had to pass a fact-filled timeline that paid homage to the teams involved with creating the rovers. We wanted attendees to absorb the caliber of engineering behind the rovers before seeing them up close and get hooked right away on the Google Lunar XPRIZE's mission to promote space travel. By indirectly guiding our guests with the use of well-planned lines, we established a natural hierarchy of content within the venue.

The use of shapes, whether geometric or organic, add

dynamic elements to a space. Shapes are defined by boundaries, such as color or lines, and are often used to emphasize or fill a bland space. Everything is ultimately a shape, so thinking about the various 3D objects within your venue helps when trying to conceptualize how it all will interact.

Negative space is one of the most commonly underutilized and misunderstood aspects of designing scenic elements for a venue. Simplicity allows for a smoother flow of people, and I would rather have people stand than to fill a space with wall-to-wall seating. The parts of a room that are left open help create a natural space for people to congregate and network. I know planners who will purposely remove seats from a keynote room to make it appear fuller— they love the "standing room only" vibe and demand this creates. Using negative space can also help create natural flow around a focal point you want your attendees to flock towards.

When thinking about the unique design of a venue, I often find inspiration in art. A modern museum exhibit is a great place to see a calculated use of negative space. I've been to a few exhibits where a museum will place a single sculpture in the middle of a marble floor, so the viewer is forced to consider the object without the distraction of other pieces. Other memorable exhibits include ones that draw your attention to a place where you least expected art to be, the ceiling, and even the threshold of a doorway.

Much like color and space, texture involves psychology of association, too. Because everyone has

a unique history, we all have an individual set of associations when it comes to certain attributes. For instance, a setting that boasts of entirely sleek, shiny surfaces is going to come across as more modern and austere than a more rustic venue that has hardwood floors and iron hardware. Rough textures often imply the opposite of modern, and while rough surfaces can be natural, they can also appear primitive but manmade, in order to elicit a certain feeling from attendees. Rough-hewn timber, burlap, and wrought iron are all just as rough as seashells, bark, and rock. Depending on its other qualities, a rough texture can conjure up associations such as simplicity, rawness, or artisanal skill. Other attributes of the texture can determine if your design scheme comes off as sophisticated, playful, comfortable, or master-crafted. In order to understand this aspect, you'll have to spend some time conducting field research!

A starting point for honing in on the elemental building blocks of design can be as easy as analyzing what about a space is so great. The next time you are out to dinner and are enjoying the vibe of the restaurant, notice as many working factors as possible. What kind of lighting do they use? Is it above your table, or behind you? What about the background music and the detailing on the plates? What are the chairs like? What font do you wish the menu had, or is it perfect as is?

Recently, while in Napa, California, I dined in a restaurant that had custom tables with built in drawers at every seat so that guests could open and

retrieve fresh silverware. It's fun to notice these details and even think through what could be elevated in a restaurant's design. In this way you begin to understand how these design decisions work together to create an entire atmosphere, which is the basis of a great event.

I look on Pinterest, attend galleries, travel, and head to events and experiences at as many different types of hotels and venues as possible. I strive to surround myself with inspiring elements, since event design revolves around creativity. While an interior design certification can signal to potential employers, and clients alike, that you're willing to go the distance when it comes to adding more to the table, you can begin by simply immersing yourself in unique settings so that you can contribute to team discussions with valuable input.

Gone are the days of generalization; customization is here to stay, and tech is paving the way.

-Gianna

Drive Engagement through Personalization and Technology

Customer-centricity is not a new concept, but when it comes to attendee personalization, we have just begun to skim the surface of a deeper pool of possibility. We are living in a world where attendees have increased expectations in their daily lives due to the influence of platforms like Amazon, Netflix, Spotify, and Postmates. Take Netflix for example—it gives viewers access to hundreds of products tailored to their individual preferences at any given moment. Or Postmates, made popular with celebrities, bringing people whatever they want, whenever they want it. In order to compete with this level of personalized engagement, we need to leverage every tool available.

As with most challenges, dedicating yourself to an outcome will help you determine a way to get there. When I planned our experiential strategy for the Grace Hopper Celebration of Women in Computing Conference in 2015, we had multiple goals to achieve. We wanted to go beyond the obvious goal of talent

acquisition, achieved via our sponsorship booth, and create a positive brand moment that offered an experience that would foster community and inspiration for women *and* give a personalized takeaway to share with others. We worked with three female artists and three female coders to develop code that would overlay their art as a filter on a photograph. Imagine you took a photo and were able to apply a "Warhol" or "Picasso" filter to a photo, and you'll get the idea. We built four bespoke photo booths and set them up in the main convention center where there was a high volume of foot traffic. Attendees took their photo in the booth and were then prompted to select a filter from one of the female artists that was applied to create a "work of art" out of their portrait. They then had the option of emailing the portrait to themselves, sharing it on social media channels, or adding it to our stunning gallery wall that we'd built as a a seamless extension to an existing wall. The wall we built displayed hundreds of Android tablets featuring the portraits, framed as if they were part of an art gallery. Portraits were shared using IOT, and soon the wall became an art-meets-tech community statement for all to view. After the event, the portraits remained on the Grace Hopper website for those who opted in. Even better, we used a Nest cam (which we were demo'ing in our career booth) to capture live footage of the gallery that showed on a screen in our booth on the Expo Floor. Attendees visiting our booth could not only get an idea of the Nest's capabilities, but could also get inspired to go participate in the portrait

activation. This is a great example of how we applied technology to create a positive brand moment for the community that was also unique for each individual.

In a study recently conducted by Statista of over 800 conference and corporate event creators, an over-whelming majority of event professionals (88%) said they'll rely on integrated tech to enhance the attendee experience in the upcoming years. That's a 107% increase from their reported usage the previous year when the study reported a 42% affirmative response to the same question. *What changed?* Well, from smart-phones to virtual assistants such as Siri, Alexa, and Google Assistant, we have introduced technology run by AI and machine learning into our lives with great vigor. Now these tools are helping us create a byproduct that shifts the brand-consumer relationship for good. Gone are the days of generalization ;cus-tomization is here to stay, and tech is paving the way.

Like the ever-expanding "ripple effect," caused by dropping a stone in a lake, is the idea that one event, or entity, can have an impact on everything around it. We experience this to some degree within all of our events, but there is an invisible world where the ripple effect is most prevalent. The Internet of Things, or the IoT, has been around for some time now, and was originally predicted by Nikola Tesla in 1926, when he told Colliers magazine, "When (wireless) is perfectly applied, the whole earth will be converted into a huge brain, which in fact it is, all things being particles of a real and rhythmic whole." Tesla was right; today the

IoT is a confluence of smart objects and devices that collect and exchange data with the help of embedded sensors. In essence, once these devices send a message, other connected devices pick it up, and the whole system reacts. These connected devices include everything from coffee makers that caterers use to keep attendees energized, to the wearable devices and cell phones that deliver push notifications. An estimated projection suggests that there will be as many as 50 billion connected devices by 2020 in the IoT, so you can imagine the power this system will have over our guests. The opportunities the system offers us to personalize experiences will only grow: From tracking attendees' check-in process to cashless payments, we're still in the early stages of a much-bigger arena.

We understand that the IoT has immense power, but what powers it? What spurs communication to your colleague's phone and your laptop simultaneously? Maybe you guessed, since it's what powers our event marketing teams, too—data and cloud computing—and lots of it! The IoT has changed from a bunch of devices sending data to a server in a far off zip code, to something called a distributed computing fabric. In other words, many of the IoT devices themselves will analyze data and make decisions on their own, similar to the way we compare information to choose our vendors or venues. This can play out in many different ways, from personalized seating to coffee orders.

Take the students at Deakin University in

Melbourne, Australia, for example; right now, they're experiencing a personalized beverage service while walking to class. When a student approaches the school cafeteria, she receives a ping directly on her phone. *Would you like your usual double-shot latte, with nonfat milk?* She presses yes, and her order is placed, paid for, and waiting by the time she walks into the cafeteria door. No line to bother with, and she's quickly on her way to class once more.

This is all made possible by sensors, location-based services, predictive analytics, and artificial intelligence-based agents. This personalized experience forgoes fumbling for a wallet, nixes queuing, eliminates any explaining to the barista, and most importantly, saves valuable time. What's more, it guarantees customer loyalty: *Why go elsewhere for coffee when an IoT-enabled app makes it this easy to order on campus?* You can imagine how this applies to our industry. Think of the increase in content we can include in keynote by shortening lines. We can even double the number of breakout sessions and interact with attendees on a personal level, when their basic needs are handled by the ever-doting devices within the IoT.

With so much opportunity to be had in this space, taking a multi-pronged approach within the IoT makes total sense. One prong to tackle involves incorporating Near Field Communications devices, or NFC, into your event strategy to personalize guest experiences. NFCs establish peer-to-peer radio communications, passing data from one device to

another when they are in close vicinity of each other. NFC devices like iBeacon can help attendees stay connected by allowing them to access schedules seamlessly, check-in, and access precise mapping and even directions within event premises.

Similar to this prong is radio-frequency identification (RFID) or beacon technology, which allows organizers to track attendees and discover where exactly they gather, and during what periods of the day. As a planner, this grants you an exact picture of traffic flow and session relevance. Should a significant number of your attendees gather by the expo hall of your venue, take this data to heart and keep the expo hall open longer, and/or budget additional dollars to expand the expo area at your next event. Also, this technology will show you if some outliers end up wandering around by themselves. Everyone wants to feel included, so make a point of finding these guests and conversing with them. If they are new to your industry, ask them questions about what they're looking to learn. Become the resource your attendees didn't even know they needed. iBeacon might provide logistical guidance to attendees, but maintaining a position as the go-to human beacon of answers and congenial support will always remain important.

Unlike traditional paper tickets, RFID chips have a unique identifier that makes them nearly impossible to duplicate. Counterfeit tickets can be the stuff of nightmares — not only for planning teams and attendees, but for venues, too. If you have worked the day

of a sold-out event, you can attest to this. A recent YouTube video showed exactly how a counterfeiter lifted barcodes from an Instagram photo of concert tickets to forge a duplicate ticket that worked at the door. Tactics like this stir up fear into the hearts of venue owners and planners everywhere. Not only did this counterfeiter get into an event he did not pay for, but the real ticket holder was likely denied entrance with her bonafide ticket. Counterfeiters—like thieves after loot—will stop at nothing in pursuit of an extra dollar. However, since RFID-issued tickets are associated with individual IDs, you can instantly deactivate tickets or badges and issue a new one right away to the appropriate guest, should issues like this arise.

Finally, the use of apps that prompt engagement at events can provide successful opportunities for attendee personalization. One company, Double-Dutch, helps improve attendee conversations by eliminating small talk. Rather than waste time on banalities, the app prompts attendees to speak their mind on meaningful matters through a feature called "Magic Hour." People turn on Magic Hour and submit a "No small talk" conversation topic ahead of their event, or while in attendance. Since connectivity is such a big factor in an event's success, the app allows each user to choose up to six people to converse with (either before the event, or during, by way of scanning a QR code). There's a catch, but it's a fun one: The whole experience runs on a timer. Each chat lasts five minutes, and a user has only two minutes to find their next topic to confer on. All topics

and users' corresponding profile pictures load on the app in real-time, so attendees have an understanding of who they're talking to, should they want to elaborate on their points over coffee another day.

The Magic Hour feature is just a part of a the puzzle. DoubleDutch also energizes their users by connecting them with the right insights and sessions while at events. You've probably noticed the increasing amount of event management companies using data to affect an audience, but it's companies like DoubleDutch that are changing industry standards on data usage. Rather than bombard attendees with sales messages, DoubleDutch users are encouraged to consider innovative points to explore and optimize their time while at events.

One year, at Think Performance Executive Summit in Toronto, Canada, we used the idea of inspiring conversation by way of attendee data in a totally unexpected and memorable method. When the executives arrived at the venue, they received a badge complete with a unique "androidified" version of themselves. The badges had an embedded RFID sensor within them, and when guests passed by a large, digital wall in the cocktail reception, their android selves popped up and started chatting about their interests.

Can you imagine talking to your virtual doppelgänger about your zest for tennis or your favorite breed of dog? This unique and playful idea broke down the formal barrier often present at sales events, and even introduced personalized business content to

attendees later on, based on their unique profiles. At the end of the event, attendees were given bespoke bobblehead figurines of their *androidified* selves, which contained imbedded curated content, and videos based on their personal interests. The tiny takeaways would always *nod* to their summit experience, and serve as a constant reminder that our company would do everything possible to truly understand customers' individual needs. Some might think this is *too* involved, but according to another study on Statista, the majority of event goers have spoken: If a company can show that they know enough about a customer's unique preferences, they are 90% more likely to use the company's services. *Ultra personalization for the win!*

We've talked about tech, and we've talked about data, but truly personalizing your attendees' experiences will involve the infusion of creative elements to tie it all together. Once you have the master plan set and your data gathered, it's time to flesh out your event with smart, thoughtful details that truly speak to your audience in a human way. The essence of a great event comes down to an alchemy created from emotional moments and an awakening of all the senses. These moments come when you, the conductor of the event, tap into your deepest stores of creativity. Remaining consistent with your company branding while exercising creativity can be challenging, but working within your limitations doesn't mean abandoning ingenuity. Actually, I've found that

working within constraints can help bolster creativity in some ways by removing choice and giving us focus. I'm lucky enough to be working for a company that encourages outside the box thinking. That in mind, I still understand how to ground creative ideas into a plan that can be executed.

When thinking about the setting of an event, the feel of an area must match the purpose of the event and its overall ethos. If I'm producing a highly technical event, the decor may be slightly more austere and refined so that content is highlighted. A product launch might introduce more socially shareable brand moments built into the experience to appeal to the target demographic, so as to generate traction outside the event walls. Personalization becomes more important when we are dealing with new customers, but lessens when we are talking to thousands of people on a forward-thinking initiative like inclusion and diversity. There's no reason to fight for creative license in a situation where creativity would rank of lower importance than content (such as during a breakout session, where content is king), and it's always key to focus your dollars on where details matter most. Take the launch of the movie, *Lion*, for instance. Since Google Maps was featured prominently in the film, we partnered with the film studio on the movie premiere and launch party. Rather than spend money on an expensive venue and personalizing every attendee's experience, we saved money to put towards celebrating the movie itself and the talented, A-list cast involved. I never foresaw plan-

ning a movie premiere in my future, but even corporate planning has its surprises!

For the premiere, we negotiated using the brand-new Google New York cafe space, which has prominent floor-to-ceiling windows and an expansive terrace overlooking the city lights. Since it made more sense to bring personal elements from the film to life, I worked closely with the Google catering team to develop a menu that had Indian and Australian specialties, and a unique beer and wine list to pay homage to the two regions the movie took place in. I even had a live catering demo of the Indian dessert "jalebis," which the protagonist of the film pines after. The dessert is made by deep-frying batter in pretzel or circular shapes, and then soaking these in a bright, red, sugar syrup. You can imagine the delight in both watching the creation of the dessert and the devouring of it (oh, and the tantalizing smell it gave off that drew people in!). We also conducted an Australian shiraz wine tasting paired with regional delicacies that everyone enjoyed. The guest of honor, Saroo, whom the entire film was about, made a personal point of finding me and telling me how much he appreciated the special features like the Australian wines and jalebis—showing that our attention to details don't go unnoticed!

In the film, Saroo uses Google Earth to find his childhood home, so I highlighted the product by sourcing beautiful images from Google Earth, blowing them up, and installing them with backlighting on the cafe walls. The images looked like expensive artwork,

and our product was showcased in a way that helped attendees take note and look closer at the imaging. My team created demo experiences that delighted our influencer attendees. Having guests don VR goggles to experience the Google Earth demo was a creative way to expose our audience to tech they likely hadn't tried at the time and experience the service we wanted to promote in a memorable and powerful way.

Finally, we created a statement installation made up of Google tablets and phones that formed the shape of an Indian mandala. The screens played scenes from *Lion* across all the devices as if it were one large screen (our IoT tie-in). *The effect?* A creative way to highlight the cast's hard work, while subtly showing off the crystalline video quality of new Google hardware products. This much was apparent: Personalization can benefit both attendees *and* brands alike.

There's something about the way the sunset melts into the impressive peaks of Manhattan skyscrapers that begs for total attention. As celebrities posed in the waning jewel-toned light, I overheard influencers commenting on what a unique opportunity it was to explore the inside of the Google office. Influencers can get into almost any club and restaurant, but to see the inside of our office was unique and special for them. Moreover, producing the event was considerably less costly than any other movie premiere these A-listers had experienced, and this somehow made the whole event come across as a more authentic experience than flashy Hollywood premieres. Since my team had been able to transform the office in

totality, our venue rental was nil, our budget for AV setup and internet were minimal, and the cost of food and beverage was reasonable since the catering was a not-for-profit organization. The event was a true success, and I can still remember the beaming smiles from delighted guests that evening.

I encourage embracing personalization at most of the events I plan. However, when your objective involves celebrating or promoting a product, film, or outside initiative, it's ok to let that work steal the show. Personalization is important when it comes to demonstrating why clients should partner with your company, creating a more relevant experience for attendees and improving brand love, but it's not always a paramount goal when planning an event. Focus on what people are looking for and why you're planning the event; it may be exposure to the work the event centers around, a teaching or training moment, or a celebration.

Here's a critical piece of advice, and you've heard it from me again and again: It never hurts to ask your stakeholders what they want attendees to feel when entering the venue. When I planned the film premiere of Moon Shot, we wanted attendees to feel inspired by the teams that were spending years and millions of dollars of resources trying to launch moon rovers to the moon. Not only that, we wanted to showcase the human stories behind the teams using YouTube as a platform, all while creating a positive brand moment. We were able to successfully achieve these feelings in attendees without personalizing the experience, even

though there's a good chance attendees were touched in some way at a personal level at our event. Leading with questions around prioritization and vision will ultimately make your event successful for creators and attendees alike—whether or not technology or personalization is a focus.

Incorporating surprise and delight into your event strategy keeps attendees engaged while building a deeper emotional connection with messaging.

-Gianna

"Surprise and Delight" - It's all in the Details

Overhead, the belly of a white plane flashed against the sun's last rays. To the unknowing eye, the plane's trajectory seemed unassuming, but it held my eyes like a magnet. It wasn't the plane that I was interested in, rather who was about to jump from it. Very quickly the evening reception guests fell silent as they noticed the skydiver making his accelerated descent towards the outdoor reception. When he deployed his parachute with a dramatic pop, fist-pumps and applause filled the late autumn air. For many of the high-profile executives in attendance, surprise was a rare emotion, but one that quickly turned to pure delight when they found that it was one of their peers wearing the parachute!

Incorporating surprise and delight into your event strategy keeps attendees engaged while building a deeper emotional connection with messaging. Surprise is not only an exciting tactic, it can generate brand loyalty, promote social sharing, and can moti-

vate authentic word-of-mouth storytelling. I've been incorporating surprise and delight tactics into my events from the first dinner party I hosted in college and continue to sharpen and add to the tools in my "event kit" to inspire. Engaging the minds of thousands of people at global conferences can be challenging, and I have come to realize that no matter how serious the event's subject matter, there's always room for awe-inspiring elements. In this chapter, we will explore strategies to incorporate smart ways to delight your guests and promote a greater ROI on your event overall.

If you're not sure where to begin when it comes to surprising and delighting, start with something you're already doing as a nicety for guests, and reimagine a different way to amplify the attendee experience. Take something as ubiquitous as registration: Rather than hand out a water bottle with a badge, I've hired servers to greet guests with trays of healthy juice shots and homemade energy bars. At events where I knew attendees would be lining up early in the morning for the keynote, I've hired hawkers to pass hot chocolate, coffee, and bagels to reward attendees for their dedication. Hunger and sleep deprivation hinders concentration on technical subject matter, so strategically doling out energy boosts helps remedy jet lag. This will also send attendees the message that you're empathetic and anticipating their needs (a proxy for what your company will do for them, too).

Nothing dampens the day (quite literally) as a soggy business suit. Having umbrellas ready to

distribute if the forecast predicts rain as your event wraps up is another simple, low cost way to show you're thinking ahead and planning with your guests' comfort in mind. Bonus points if you brand the umbrella, since your attendees will always think of your company's kindness when they pop open that umbrella in the future! An item like this doesn't require much cost, but indicates your brand's ability to empathize. Finding helpful ways to delight your guests and reach them during moments that matter generates brand affinity and loyalty. While Google does this digitally, my job is to recreate the same impact in the physical world and bring messaging full circle.

While working at the agency Cappa and Graham, we planned a beautiful reception and dinner for a medical company at the SFMOMA. The client had asked us to come up with a networking activity for the reception, and a creative giveaway for the guests as they departed. I came up with an idea that not only surprised and delighted the guests, but achieved the client's goals, keeping their company front of mind for the upcoming year. I wanted the reception activity to have a natural tie-in to the venue's art theme, so I hired a popular local muralist, Brian Barneclo, to engage the guests with painting a large canvas together as they imbibed cocktails and nibbled appe-tizers. After the the guests completed the work of art together, they left the reception room to enjoy dinner in the beautiful atrium room of the SFMOMA. Behind the scenes, while our guests enjoyed dinner, I

had the "masterpiece" photographed and formatted into a save-the-date card. My team then printed and inserted the finished product into elegant plexiglass frames that were given out as a parting gift to each guest. From the reactions I witnessed, guests were delighted that they had a memento of the work of art they had created while bonding together at the event. It not only tied into the art-theme of the venue and engaged a local artist, but also served as a beautiful reminder to add the next year's event to their calendar.

Getting into the mind of the attendee and cultivating their ultimate event experience boils down to a few crucial factors: current events, season, weather, agenda, and location. These all create context that can influence the experience for an attendee at an event, but in order to get into your attendees' heads and make a memorable impression, it's important to analyze in advance the demographic you expect. Whether you're a creative, strategist, or producer, it's your job to visualize what attendees might be thinking, feeling, needing, or wanting while away from home at your event. This empathy can play out in a number of ways. At the Adwords Performance Forum, an advisory event for our top customers and practitioners, we wanted to get our new Android tablets into the hands of these tech industry influencers and also promote engagement at the event. Rather than just gifting devices, we customized every tablet, so when the attendee powered it on, it welcomed them with their name and a short video

we'd customized specifically for the event. The video helped attendees navigate through our event app, in a seamless and fun way. We also realized that if we expected attendees to use these tablets throughout the duration of the two day conference, they'd have to keep them charged up. So, as I designed the general session seating, I took care to build out different styles of seating, each with charging ports conveniently located on arm rests or tables. I also had programmable tech lockers installed for attendees to use, so when they wanted a digital pause from their new devices, they had a safe place to stow them away.

Sometimes the surprise and delight comes in the form of relief, a solution to a pain point. For an Advisory Board event in Scottsdale, Arizona, the forecast was unseasonably hot at 115 degrees, and we found ourselves in a bind having planned an outdoor, midday meal. With some quick thinking, the entire outdoor seating area was made comfortable for guests by the addition of misters, tray-passed, icy-cold washcloths (we purchased hundreds), fresh granitas, and gelato carts. We also placed branded sunscreen and sunglasses on all the tables and created a "hydration bar" with ten different types of infused icy waters to remind guests to stay hydrated.

One zero-cost way to surprise and delight is a tactful schedule change. We are all ruled by time, and it goes without saying that people are more receptive at certain times of the day than others. Playing with the normal timeline of an event can boost comfort levels and engagement. At one event I planned, we

purposely started the keynote in the evening rather than first thing in the morning, when it had been hosted in years prior. The event was high-end, with a focus on compelling content and community building, so the absorption of ideas was a pivotal metric for gauging the success of the event. When attendees filtered into the general session room, we treated them to champagne passed on trays and a selection of canapes. The laid-back, but suave, spread was an unexpected and welcome surprise, and a stark contrast to previous event schedules. For the many attendees still feeling drowsy from jet lag, the treats and unexpected bubbly cured travel tension.

After relaxing and settling into hotel rooms, guests are revived with the energy of inspiring conversation rather than a generic welcome reception. An article published on Vice in 2018 confirms that some people are naturally more creative and collaborative in the evening, so we built a more inclusive conference by creating opportunities for these folks to participate when at their peak. Flipping the script on the timing was successful and set the tone for a positive next two days at the conference. Surprise and delight can even be used strategically. Take the aforementioned example: If you know you are going to have a line of hundreds of people lining up for your product launch event or keynote session, hiring vendors to hawk donuts, granola bars, and coffee to your eager attendees will not only delight your attendees as they wait, but it'll prevent people from hitting your buffets hard once they're inside the event venue. As a bonus, if

they're served in cute branded carts, attendees may be delighted enough to post on social media, extending your reach and creating buzz. By taking care of a need, you're also in control of the flow for the first session of the day, setting up the rest of your event for a smooth progression.

Finding potential pain points to instill surprise and delight moments within your own event comes after you iron out your attendee's event journey. We've been over the gist of an attendee journey pre-event, but for the actual event journey, you'll need to ask a bout of different questions. Within your team, find answers to questions like, *Will the location of a particular session increase or decrease the attrition rate?* and *What are the can't-miss experiences or sessions that we want all attendees to see?* or *How can we connect our session content to our demos in a cohesive narrative?*

You're used to these types of questions by now, but keep in mind: It's important to make sure you're on the right track from the start. Conduct focus groups, or insight research, to garner primary data points which can aid in identifying moments that can be improved in your event cycle. My husband fits the tech product manager demographic I frequently plan for, so I'll often run concepts by him to make sure they resonate. Find out what skills your attendees would like to learn, or the information they are most interested in hearing about. This feedback can alter your overarching surprise and delight strategy, and improve the communication cycle and experience within the event.

. . .

It wasn't too long ago when our private email addresses were relatively private. Now, mass email marketing hits our inboxes with millions of unsolicited marketing emails, touting products and services that we may have little interest in. If you want to garner a response from your attendees, you must do the things that instill trust, value, and connection. Infusing your experience with genuine sensory pleasantries can demonstrate that there are still humans behind all the digital solutions. Targeting all five senses can help your team serve up new and engaging experiences for your guests.

SIGHT: When incorporating visual elements into your surprise and delight strategy, it's paramount to consider the environment you're working with and what emotions you want to elicit in your audience. I've found that one way to add a unique feature into any space is through the use of a cleverly designed wall. I'll often use a wall as a creative element, because they're already a necessary component of events that often benefit from design enhancement. Moreover, a wall is obviously a highly visible scenic element, and can be worked into a multi-purposed set piece. I've had living walls fabricated for event themes with baked in branding, that inspire photo-ops. Some have revealed messaging when the room's lighting dims. Things that normally lie flat can be elevated onto a wall, placed on circular shelves, or even dangled from clear fishing line.

At one breakfast buffet, rather than keep trays of bagels in their normal horizontal heap, I had a wall dotted with pegs so that each bagel complemented a visually pleasing array. Not only did the floating bagels liven up the breakfast area, but they also served as a fun piece of art *and* saved me the space that a bunch of pastry-filled bowls would have taken up. Whether it's used to promote your brand or simply add playfulness to an area, a bespoke event wall can change the dynamic of a room completely.

For one cyber-security summit, I knew my demographic was predominantly male with a penchant for high-quality caffeine. This was just around the time when a new coffee trend was taking off. This "bullet-proof coffee" is made by blending coffee with butter and coconut oil and provides a long lasting burst of energy. Even better, the name tied in perfectly with the security theme! Moreover, the distinct coffee flavor provided a high-octane energy boost for attendees, so their senses stayed sharp during the content and discussion sessions; cue a rush to the senses, *and* a clever way to tie the stunt into messaging.

Another way to harness stimulus into an event relates to the way our brains work when we see an object. Whenever we scan a scene, our brain does a lot of work to attribute a pattern of retinal firing to our internal interpretation of what lies before us. This makes for a slightly slower process of interpreting information than when we absorb info through our other senses, but it means we're more apt to remember something we're seeing for the first time if

it relates to another object we're familiar with. I find this becomes especially useful during product launches. In fact, in order to promote the Google home mini, an entire campaign was set up to surprise and delight people by associating the mini with a universally accepted treat, the beloved doughnut.

Since the Google home mini comes in dark "Charcoal," light "Chalk" grey, a pinkish orange "Coral," and a minty blue "Aqua," these colors were used in a playful promotion that ultimately swept the nation. An "insta-worthy" adorable doughnut truck came to life and took the activation to the road for months. Inside the truck, a Google home mini was stationed so that people could ask the tiny device a question and engage first-hand with the product. Each participant was then rewarded with a cute, colored box. Opening the lid, they were greeted with either a delicious doughnut (which came in red velvet, blueberry, and chocolate coconut, to mirror the mini color scheme) or, a Google home mini!

Before guests even opened their box, they were posed for pictures next to the truck, and the surprise and delight aspect of the event was enough to create a small cult-like following as the activation traversed the country. One Reddit comment even read, "The whole experience was enough to send me out and buy three minis for my sister's kids. I just couldn't stop thinking about how deliciously cute the thing was!"

Even though the mini is seemingly as far away from a sugary convection as can be, the tech product benefited from being associated with a revered symbol

of happiness that anyone (and not just the tech-savvy movers) could connect with. In this way, the association inspired people to quickly identify with the product, and to remember its convenient dimensions and fun coloring in a more relatable experience, which varied greatly from the branding of competitors in the assistant device market. Of course, most products don't resemble treats, but an important takeaway remains: When advertising a new concept to an audience, they're more apt to remember the product if it's connected to something they know and love. Bonus points for those able to craft witty installations clever enough to inspire a smile.

TOUCH: When it comes to touch (or haptic) sensations, humans have super-fast reactions, so attendees are likely to be most surprised by a strategy targeted at this sense. When we feel something hot, our motor reactions are instantly triggered without higher-order cognitive processing. Anytime an attendee feels a drop in temperature or a texture out of the ordinary, their reaction will be instantaneous. For this reason, comfortable soft-seating is a great way to surprise and delight guests. If your company regularly offers massages to its employees as a perk, perhaps you can bring in massage chairs for your events. Tuck these premiere seats into vignettes or even hide them as part of a regular seating set up, and you'll delight your attendees while nodding at your company's culture. At one private film screening I planned at SXSW, attendees only realized how comfortable they were about to be *after* settling down.

Through the use of several different massage settings on their unique chairs, they quickly discovered they were in for a stimulating talk *and* back knead!

Another haptic touch point to hone in on is the transition between outdoor to indoor settings, and vice versa. The provision of blankets in outdoor settings never goes under-appreciated, and conversely, the offering of cold beverages or aforementioned cool towels right inside venue doors instantly reinvigorates attendees. Bringing the outdoors indoors is another unique way to infuse your event with surprise and delight and quite literally can "liven" up a corporate space. At one summer event, I welcomed a very mature C-Level attendee group with a playful lemonade bar set up and a tree placed by the registration area with doughnuts and cronuts dangling from branches like ornaments. The event came right after New York City pastry chef, Dominique Ansel, invented the cronut, and I thought attendees might appreciate a taste of the new craze. The cronuts weren't merely sweet treats, but also symbolic of the hybrid cloud computing solutions we would discuss in keynote. Yes, the connection was a little far-out, but the blend of donut and croissant, *did* tie into the theme of the conference. With their minds already creatively conditioned to a favorable hybrid experience, they snapped a number of shots before the cronut tree, then bustled into their seats to take in the technical talk.

At another event, I offered attendees a unique way to engage both their hands and their taste buds in

another example of bringing the outdoors inside. The surprise came in the form of little potted parsley, dill, basil, cilantro, and thyme plants, set up as centerpieces on the lunch tables with placards touting, *Add me to the grilled salmon!* or *I taste great in the risotto!* Using mini sheers, guests clipped herbs directly onto their meals like a cook might do in a country kitchen. The interactive element spurred pleasure and conversation while serving as an icebreaker for guests as they experimented with different herbs and flavors.

TASTE: As you can well imagine, one of the most prolific ways to incorporate surprise and delight into an event is through taste. Since food plays an essential role in every event, it's truly the perfect medium to use when inspiring attendees. From the set-up to the way it is presented and finally tasted, meals offer a large opportunity for the infusion of creative elements. Food has served as a connecting power since the beginning of mankind, and incorporating different tasting stations at events can unite people from diverse cultures and industries. At one event, I used a unique prop to play a central role in featuring the final act of the night—the great wall of cake bites. Channeling my love of a bespoke wall, I had dozens of tiny holes drilled into a 6' by 5' wooden board, for the strategic placement of shiny silver forks. These then balanced delicious bites of cake: hazelnut, red velvet, blueberry cheesecake, key lime, chocolate torte, and caramel pecan; each with a unique color that lent itself to a truly spectacular mosaic. Not only was the wall stunning, but it took into account the

very high level VIP audience, many of whom preferred just a bite or two of dessert. The edible art wall of cake was so well received, that I recreated it again later on at another high profile dinner at CES one year, where it was received once more with smiles, pictures, and delight.

If your brand revolves around taste, it goes without saying that you should capitalize on this sense when planning your event tactics. I was once invited to an exclusive dinner in San Francisco, hosted by Nespresso, in conjunction with the America's Cup. They had planned a seven-course meal, each course designed by famous chefs including Thomas Keller of the French Laundry. Each chef was charged with using a specific flavor of Nespresso in their signature dish which was then paired with an outstanding wine. Chef Keller prepared lobster in a chocolate/espresso sauce paired with a pinot noir. It was the most unusual but elegant combination of ingredients that I've ever come across and certainly unforgettable.

HEARING: Sound can also lend itself well to surprise and delight moments, if manipulated with tact. Music has the ability to set the mood and create memory recall in attendees. Have you ever watched a horror film without the sound and noticed how much *less* terrifying it is when the ominous music has been silenced? The absence of sound can also be noticed and can sometimes be overlooked by busy planners. I make sure to always inquire about whether we can pipe in upbeat or calming music to our registration and meal areas at events to create a positive vibe,

especially when the venue hasn't filled up yet. To this day, I myself associate different types of music with different activities. My nanny knows that I love listening to jazz while preparing dinner (likely learned from my own parents' habit), and as soon as I walk in the door after work, she switches the music to Stan Getz (using our Google home mini of course!). It not only calms me and helps me make a mental switch from work to home, but my son has come to associate it with positive recognition as well.

We grow accustomed to voices and noises we hear, even while still in the womb, and come to associate specific sounds with events, times of the day, and other Pavlovian triggers. Because we not only hear sound waves, but feel them in our body, sound has a powerful effect on us. When interacting with this sense, I like using it for powerful moments or to liven up transitions. This has taken the form of a marching band to help guide attendees back into keynote sessions after lunch and even chirping crickets when attendees step inside a vignette with an outdoor theme.

Furthermore, we all use sound to effect change every day through speech, and I would go so far as to say that the human voice is the most powerful sound on the planet. At a women's leadership summit I produced, after the CEO of YouTube spoke, she welcomed to the stage two well-known teenage YouTube stars who were known as backup acts to Beyonce. Our CEO interviewed them, and then they broke into a live, fully-produced performance that

nobody anticipated. After hearing their story and witnessing their authenticity, attendees were so impressed that they gave a standing ovation.

Just like the YouTube stars, anyone on stage has the opportunity to surprise and delight an audience as all eyes are fastened to the stage. While members of a leadership team typically talk to an audience, they can go a step further and come across as more thoughtful by addressing attendee concerns directly on stage. At a recent event, rather than ask questions of the audience (which can be intimidating for attendees), my team created an anonymous questions box where guests could jot down anything on their minds. Later, company leaders addressed the comments candidly on stage. When attendees feel their voices heard, they begin to have a positive connection with your brand and share their experience naturally over social media channels and by word of mouth referrals. In a world increasingly saturated by sponsored ads, these genuine posts do more for your brand than an expensive, influencer-pushed advertisement.

Even for social events, surprise and delight is an essential element to engaging your guests. When hosting dinner parties, I always incorporate surprises to generate conversation, or simply bring a smile to guests faces. One of my favorite tactics at seated dinner parties is to create questions on small pieces of paper and hide them underneath the salad plates. After the salad course has been eaten, the plates are cleared to reveal the tiny conversation-starters. This helps redirect the conversation, should one person be

monopolizing it, by giving everyone a chance to ask their designated question to the group. I also enjoy serving food in unexpected ways. At a home dinner party, people aren't always expecting a palate cleanser between courses, but I like to serve a playful version of this high-end dining practice. I'll scoop out the inside of a lemon or lime, then fill them with lemon or lime-flavored sorbet so guests appear to be scooping out the tangy fruit. Or, I might deconstruct a standard dish. Take a pear and goat cheese salad: Rather than serve it on a plate, I'll slice each pear into horizontal sections and then re-stack them back together, layering in the spinach, goat cheese, and dressing I would have put in a salad. Simply presenting food in a creative way sets the tone for a unique and memorable experience.

I've even experienced surprise and delight myself while on the planning side of events. Vendors, agencies, and caterers take note: Delighting your client is a great way to instill confidence and retain future business. While planning an event at the W Hotel in San Francisco, the hotel staff did their research and discovered that I had a wine blog, Decantress, and had recently received my sommelier certification. When I checked into my hotel room, they'd taken the time to set up a custom "blind tasting" for me to partake in. They hand selected a special bottle of wine, removed the label, and printed out the standard blind tasting sheet used for the Court Master Sommelier test. To enhance the amenity, they added a beautiful and tasty spread of fruits, nuts, and cheeses to

enjoy while sipping and evaluating the wine. This wasn't an expensive nor flashy gesture, but a playful and thoughtful one that was personalized specifically for me. That the hotel team was willing to go above and beyond to delight me, not only made me want to work with them in the future and share my experience with others, but instilled in me a confidence that they cared deeply about my guests' experience as well.

SCENT: Have you ever walked past a bakery and the overwhelming smell of baked pastry stopped you in your tracks and lured you in for an impulse purchase? And who can miss the tell-tale scent of sweet funnel cakes that immediately conjures up a festival. Scents have the ability to ignite memories and elicit feelings in us. They can be fun to use at events and experiences, though I use this tactic less frequently than the others I mentioned. I like using organic scents when hosting events, so they don't overpower or offend guests who are sensitive to artificial fragrance. Fresh herbs on tables or in a speaker greenroom bring a freshness and invigorate attendees without offending. When planning food service, I love to incorporate a live cooking demo; the scent helps draw attendees in and you can't beat the freshness when food is cooked to order. Hotels are famous for using scent as a tactic and spend millions of dollars on piping their "signature scents" into their venues. This leads to brand recognition and consistency between different properties of a chain. In fact, some hotels even sell their signature scents in the way of candles and fragrances! I typically use scent when planning

social events at my home. I always light candles before guests arrive and switch out the scents based on the seasons. When guests walk in the door, they're immediately hit with a warm ambiance and inviting aroma, even if dinner hasn't been cooked yet.

Finally, no matter what strategy you choose when incorporating surprise and delight into your event, it's important to also consider the fundamental principles behind inclusiveness. Contrary to the messaging in this chapter, I hope the following best practices for planning with inclusiveness and accessibility *never* come as a surprise to your attendees. Planning with accessibility in mind is paramount, and I always make sure to plan events that are for everyone. Surprise and delight need not always be about shock-and-awe. As event planners, we're hosts, and our goal is to make guests feel safe, welcome, and included. I always make sure that we reserve seats in our keynote room for companions, and create aisles that are wide enough and tables set at the appropriate height for those in wheelchairs. We also provide communication access via real-time transcription (a.k.a. CART or closed captioning) on screens for those who are hard-of-hearing, and hire professionals who can interpret keynote into sign language if requested. It goes without saying that you should inquire about dietary restrictions on your RSVP form, but these days, this is the bare minimum. You should remember *all* types of attendees, and reserve space within your venue for mothers' rooms and prayer rooms. If you can, offer childcare at major conferences, too, or at least a stipend for care so

that working mothers can attend and have peace of mind that their children are properly cared for. During the registration process, allow attendees to choose their own pronoun stickers in order to better identify with their preferred gender. In today's climate, it is the job of event planners worldwide to champion people of all types and welcome diverse groups to events by way of featuring additions that provide comfort and security.

At the end of the day, events should serve a purpose, bring people together, and create memorable experiences.

-Gianna

Plan Corporate Events like a Professional

If you pull up Pinterest, searching for "event" or "party" quickly turns into a harrowing feat of sorting through far too many pin-able options. As square after perfect Pinterest square crops up, the hordes of clever, adorable ideas just seem downright overwhelming. If you're like me, you've felt Pinterest fluster: that moment when we wonder, *How will I organize all these perfected tidbits of inspiration?* Funny enough, if motherhood has taught me one thing, it's that less time actually helps curb distraction, and forces me to focus.

As a new mom, my conscientiousness of prioritization probably comes from the fact that I no longer have endless hours at my disposal to spend on Pinterest (as much as I would admittedly still enjoy this). Budgeting matters more than ever before now, too, and when gearing up to host a social event, I'm careful to sort through various cost options. I actually view constraints as gifts now, because they force me to

become an even more creative problem solver, and keep laser-sharp focus on whatever I'm trying to accomplish. Strategies materialize when I'm trying to achieve goals more quickly, and the results serve the overall event better. Less time means less add-ons that can overwhelm guests with too much sensory noise. I plan the important details, and start by focusing on the elements I want to impart to my guests. I keep one thing in mind with social events in particular: We are practicing the art of making memories, so make sure they're the ones you want your guests to retain!

When planning social events, people often forget to begin with a goal in mind. To my fellow event planners, this would be unthinkable, but of course, it's a normal thing to forget when you don't plan events for a career. I dedicate this chapter to any hosts kind enough to entertain others. I hope to impart tips from what I've learned from producing results-driven events for Fortune 500 companies for close to fifteen years.

When coming up with a goal for an event, think beyond the social norms for what is an acceptable reason for a party. As a fun exercise, let's play with this concept of an Oscar viewing party and see how we can extend it to occasions for a party with different goals. For example, a friend of mine once wanted to promote her new costume jewelry line in a unique and fun way. Rather than simply call friends and supporters over for an event strictly dedicated to viewing her pieces, she chose an unexpected avenue

for showing off her jewelry. Knowing how much people like dressing up for Oscar parties to celebrate Hollywood's biggest night, she organized a pre-Oscar event at which she sold her jewelry to a very receptive audience. It was a smashing success!

How about an Oscar viewing party to sell a home and show prospective buyers what it feels like spending an evening in the space. Hosting an event is a great way to build excitement around a product, and if you can couple it with a national phenomenon, you're likely to get more traffic. People will get to know the layout of your living room, kitchen, and adjoining areas more intimately than if they'd strolled through during an open house. Those who stop by might guess that the party isn't entirely centered on viewing the Oscars, but when they begin to enjoy the appetizers and drinks in an inviting setting, the whole event will begin to feel festive and natural. Whether you believe it or not, an Oscar viewing party can be a great medium for providing hands-on exposure to a new product (no matter the price tag), so long as the party's structure makes sense and ties into the main draw. And if the party is well-planned, the guests who attend your event will likely share on social media and by word of mouth, extending your advertising dollars into a strategic investment rather than cost.

Anecdotally, my Oscar viewing parties have tended to be purely social gatherings; a time to gather with friends to celebrate the Hollywood awards season, while sharing our opinions of the year's cine-matic wins. If it's been hard to get in touch with

friends and family members, a national event like the Oscars is an opportunity to solve a problem for them (where/how to watch/celebrate) and let your hospitality skills shine. Of course, you also fulfill your goal of spending time with friends or family while watching Hollywood's biggest night. Now, you can scale your resources up or down depending on what makes sense for you personally. I've gone all-out when my time and budget permitted. Other times, I've relied on outsourcing and still met my goal of bringing a fantastic group of people I love together. There have been times when I haven't even had time to shop for florals, but I've created highly effective centerpieces by gathering objects from around my home that fit the theme. One year, I gathered all types of gold-hued tchotchkes in varying shapes and textures, clustered them together in groupings (pro designer tip: use groups of threes!), and created stunning and effective centerpieces perfectly on theme for the Oscars. If cooking isn't your thing, try a delivery service like Postmates, and order up award-worthy food (bonus if you theme it around one of the "best picture" film nominees). In a half hour or less, you, your family, and your guests will be enjoying the benefit of perhaps our society's most wonderful short-cuts.

It's fun to meet new people and what better way than a party? One of the best ways to expand your network and shake up your guest list is to ask current friends to bring over friends of theirs that you've not met yet. Consider attaching a rule to your invite: Each

guest must bring a plus-one that the host doesn't know. With new people at your event, you'll likely need some icebreakers or activities to help soften barriers. One fun adult-event activity I love is blind wine tasting. Kick it up a notch (and your budget down one) and ask people to bring a bottle of Champagne, Prosecco, Cava, or their favorite sparkling wine, all sheltered in a paper bag. It doesn't hurt to have a few extra wine bags in case your guests forget to cover up their wine (I always think of contingencies, even when planning social events). You can use this to conduct blind tastings which will not only speed up socialization, but always serves as a fun way to learn something new about your guests and their wine preferences, keeping the mood fun, light, and social.

For the home chef wanting to build your online brand, a dinner party is a fun and valuable way to test out a new recipe or try a new wine pairing with your special dishes. During a period where I wanted to learn how to roast the perfect chicken, I started honing my recipe every Sunday until I had nailed it. Since it was nearing New Year's Day, I hosted a New Year's dinner party where people are craving comforting foods before hopping back on the diet wagon. We celebrated a great year by opening a beautiful bottle of white Burgundy that paired perfectly with the dish. The beauty of serving the roasted chicken was that after preparing it, I could then leave it in the oven for an hour to cook. This allowed me plenty of time to engage with my guests and then

serve up an impressive and flavorful meal with ease. One great way to practice and perfect crowd-pleasing treats is to host an event correlated to an upcoming holiday (the more unknown the better, this allows for recipe ambiguity) or in conjunction with another recurring gathering. I was a member of a book club where we not only came together once a month to share our thoughts about the fiction we'd just read, but to enjoy a themed dinner together. The host would select the book to read for the month, and when hosting us, would prepare a dinner spread that correlated with the book. For instance, when the book I selected took place in India, I prepared a fun and aromatic "curry bar" where guests could add toppings of choice to the coconut rice and spice-laden chicken curry I'd prepared. This worked for the group because we all enjoyed showing off our cooking, and this provided the perfect forum to meet both objectives.

You could simply be looking to try a new treat, like champagne jello, or need an excuse to uncork a bottle from an overindulged wine fetish. Whatever the occasion, having a social event is a great opportunity to imbibe unique food and drinks, explore new conversation topics, and even test out recently honed skills. Whatever your goal is, stick to it, own it, and come up with a crafty draw so that you don't have to star as the center of attention for the entire evening, but rather can sit on the sidelines and contribute as much as you'd like.

At the end of the day, events should serve a

purpose, bring people together, and hopefully create memorable experiences that are worth the investment. Take some pressure off yourself and tune into what's most important to you. Focus on these important details when striving to meet your goals. When you are focused, your guests will take note and have a more engaging and memorable experience because you're driving, and they can just sit back and enjoy.

There's a special feeling that comes over us when enjoying that perfect dinner party. The evening is intimate, personal, and the energy and flow make us feel a magical connection with the experience. When we leave such a special social gathering, there's a lasting feeling of gratitude and goodwill that warms our core. So, what factors can we attribute to a night of such caliber? Was it the food? The lighting? Perhaps just the right blend of people? The truth is, it's likely a combination of a whole myriad of things, but they all stem back to the choices made by the person who orchestrated the evening that blended every element together into a beautiful symphony—the ever-attentive, gracious host.

As a regular host, I fully appreciate how rewarding it is to create a truly enchanting event. If you've ever organized a social event, you know that hosting is a true art form. As the host, you've willingly taken on the role of providing everyone else with the best experience possible, while committing yourself to hours of work behind the scenes. It always takes longer than you anticipate to prepare everything for a proper social event, so I always start preparing a day

or two in advance as much as possible. I set the table, make sure all the dishes and glassware are spotless and the centerpieces are completed. I even chop and prepare the *mis en place* so that all I have to do the day of is cook pre-prepared ingredients. In a way, it's a bit like a cooking show; the guests get to see only the entertaining parts and none of the mess!

The whole undertaking of a dinner party can get expensive since there isn't a company backing your budget, so you might want to consider creative ways to stretch your dollars while planning your menu. I can assure you, the seasoned host has developed strategies to cut costs while delivering a lovely meal and evening. There is no harm in staving off premium spirit costs and opting for more budget friendly options since, after all, your guests will be there primarily to enjoy your company. And if they're good friends, they won't want to see you burn a hole in your savings at their expense. If you know what to look for, there are plenty of high quality options between cheap and expensive. I always say, "Anyone can order an expensive wine, but it takes a pro to be able to order a good *and* reasonably priced one." Pro tip: When selecting wines, choose regions where it's less costly to produce wine and hence the prices are lower without sacrificing quality. Think Australian Shiraz or Argentinian Malbec instead of Napa Cabernet or French Bordeaux. Try Spanish Cava rather than French Champagne. And there are plenty of reasonably priced German Rieslings that pair much more

beautifully with food than pricey California Chardonnay.

Like any type of event planning, hosting is best learned through doing and working to perfect practices through repeated attempts. I grew up watching my mom (aka "the other Martha Stewart") host impeccable events and learned many of my hosting skills from her. From the time I could ride a two-wheel bicycle, I was witness to the little things an excellent host does to perfect an event. My mother was the best role model I could have asked for; she taught me so many ways to make people feel personally welcome in simple, yet inventive ways.

Take seating for example—there are so many ways to instill character into place cards. If you've invited six or fewer guests, it's reasonable to allow guests to seat themselves because everyone will be seated close enough together to converse as a table. With more people, place cards settle confusion on who should sit next to whom, and if done well, can actually be a strategic way to get people talking to folks they might otherwise never have a chance to connect with. My mother always had me help with this part of the prep work for whatever dinner or special gathering we were hosting at our home in Los Gatos, California. For Christmas dinner, Mom and I would set the dining room table with a different theme each year. Often, colorful ornaments adorned with each attending family member's name would serve as festive place settings. The youngest members of the family wouldn't squabble over who

sat next to whom, and everyone would have a personalized memento to remember that year's holiday party.

Later in life, I applied this same trick for dinner parties. During summer, dinner guests might find their names written in cursive on bright lemons. When the days grew shorter, and autumn came with cooler temperatures, I sometimes etched guests' names on mini persimmons, or palm-sized pumpkins. I always choose to decorate with a purpose, and I find that seasonal fruit or foliage place settings bring cohesion and color to an empty dinner table. What's more, if you're planning on a budget, fruit or foliage found locally is practically free and embraces the "bringing the outdoors inside" discussed before.

When there's more time for planning, I truly have fun with it, and have my sister or friends over for crafting sessions. For one dinner party close to Easter, my friends and I pricked holes in the tops of eggs and blew the yolks from the inside out. These hollow eggs were labeled with loved ones' names and became the ornaments that would hang in windows to serve as pastel reminders of our shared festivities. My personal favorite came after Garrett and I exchanged vows. My father used a sword to saber a bottle of champagne open, much to the delight of our friends and family, and as the applause erupted, guests received champagne flutes with personalized vintage wine charms with their names and table numbers etched onto them. The old adage, *It's the thought that counts*, applies as much to hosts as can be, and when guests see their

names presented in fun ways, you can be sure they recognize the thoughtfulness behind the gesture.

Ever the important building block, some basic strategizing should be done to prepare for your formal dinner party. When we look to history, the power of a dinner party is scribed throughout the ages for being a way to bridge different people and celebrate common goals. Thomas Jefferson was famous for using the dinner party to expand his and his guests' horizons at both his plantation in Monticello and the White House. In fact, Jefferson was known to host dinner parties at the White House nearly every night in order to break down the political divides between Senate and House members—as deep and wide as those today. While Jefferson's staff would wake at dawn to begin preparing for his nightly party, you can cut down the time it takes to host a well-thought-out meal by preparing much earlier than you think necessary. In the corporate realm, you have a team and can manage a tight timeline while fielding surprises that arise. However, when you don't have the help of a team to back you up, adding a cushion of extra time is really one of your best safeguards. I've never heard an event planner who said they had too much time!

Save yourself the perspiration, and choose dishes that you can make for your party a day or even a few hours in advance of your soiree. If you truly want guests to have a completely homemade meal, breads and baked goods can be made at least a day before. I like making foods that improve over time: mushroom ragout, brines, some desserts, and certain dressings

and sauces all fall into this category. When I'm cooking dinner for my family on any given night, I balance the dishes so that I have several pans cooking in the oven, and only tend to one on the stove top.

I have finessed getting each ingredient cooked within a few minutes of each other, but still, for dinner parties, I make sure that whatever I'm making that night isn't so complicated that I have to watch the stove while my guests sip wine in my living room without me. As a rule of thumb, I try to cook most dishes in the oven when hosting (less smoke, less time-intensive), and stick to the stove top for finishing any final preparation. Everyone will be more impressed if you have everything ready to go ahead of time so that you can socialize instead of sweating away like Jefferson's staff in the kitchen.

Digging through drawers can be deftly avoided when you choose to set out the exact serving utensils and dishes needed to plate everything ahead of time. When setting a buffet spread, I like to set out all the empty serving dishes in advance and label them with post-its, so I know exactly where the food will go once it's been prepared. It's also perfectly fine to ask your earliest guests to help in some capacity, and I can assure you everyone enjoys participating. As host, remember that your guests have likely arrived early since they *want* to get to know you better. After initial pleasantries are exchanged, ask them to choose a bottle of wine to open (even if you only have two out, it's just the thought that matters) and treat them to the first glass. If there are any last minute finishing tasks

like lighting candles, or writing names on guests' wine glass tags, ask your friend to do the honors. As humans, we subconsciously feel better when we're contributing to a gathering, but assisting doesn't always have to be a completely selfless act. I once asked a shy friend to go around and fill other arriving guests' wine glasses, in order to allow him an easier way to ingratiate himself into conversations. Pouring wine into another's glass is a deceptively simple trick to break the ice between strangers. When your guests join you in your mission to make the evening a special one, feelings of camaraderie will spread throughout the entire party.

When it comes to the food served, everyone can agree that a well-cooked meal can serve as a catalyst that brings people together, but again—it shouldn't come at the expense of the host. If you are like me, you have more than one recipe you think is best suited for your event. I recommend creating a basic spreadsheet to organize the ingredients, steps, and prep time needed to pull off the cooking of your chosen meal. By creating a recipe spreadsheet, you can sort your recipes in many ways: by name, type, or even key ingredients. I recommend using rows for each category heading, for instance— "Recipe Name," "Main Ingredient," "Course," and "Preparation." I used a spreadsheet for one elaborate Easter dinner party, laying out everything I had to do for three days in order to prepare down to the last minute. While the timing for each ingredient was practically ingrained, plotting everything out helped me think through the

cooking processes of each dish. This isn't dissimilar to the way I juggle multiple projects at work, and ultimately, applying the same set of rules I practice for large scale events is just as helpful for smaller parties. Rather than look at every detail, I create a 'milestone' timeline with just a few key moments to use as my anchors throughout the preparation process. There's no reason why your guests should ever be kept waiting because you weren't able to time your meal preparation properly: The sign of a good planner is one who keeps the flow of the evening going. She or he can read the room and know exactly when to serve the first course and offer dessert, or step in with a subtly-placed icebreaker.

A wedding day is one of the most special days a person will experience, but every bride (and groom, too) plays the ultimate host at their wedding to some degree. A wedding day is symbolic of major change, so it only makes sense to feel a fair amount of pressure in kicking off your life's next chapter smoothly. However, take it from a former bride: Leaving last minute execution details up to a seasoned professional allows you to be present and enjoy the once-in-a-life-time experience with your beloved guests.

I highly recommend hiring a day-of wedding coordinator to allow you to focus on yourself and your guests as you prepare to walk down the aisle. Since it takes *months* to have a wedding dress altered, the last thing you want is to make any rogue movements while tracking down misplaced centerpieces and tear a carefully stitched seam. A wedding coordi-

nator's job is to make sure the logistics are buttoned-up, so you can spend your worries on memorizing your vows or practicing your choreographed dance. I might be a seasoned event planner, but I also knew that, given the nature of my job, I'd have periods when I would be too busy with my corporate events to properly focus on my wedding. I opted to choose an event coordinator who was willing to work with me on an hourly billing basis, as often as I needed her. One thing I had her help me with at the start was pulling together a detailed timeline for the wedding day (weddings have a very particular set of details and deadlines that are unique from corporate events). I then had her help me with things that were time-consuming, such as whittling down a massive list of event photographers to the top five, and from there I could make the final selection. Since the amount of resources budgeted towards a wedding can be substantial, allocating just five to ten percent of your budget for a coordinator can ensure that last-minute snafus don't affect your mood. After all, no one wants to be a problem solver on their wedding day! It's also okay to set a budget and share it up front with your coordinator. I set a budget, then checked in monthly to see how we were doing, with the overarching caveat being we could not exceed the budget I'd allocated for her services. This afforded me the peace of mind I needed to make sure deadlines were being met, and I had a second set of eyes and hands when I needed them, while still being able to manage the majority of the planning myself.

When thinking through who to invite to your wedding, don't forget that you will inevitably have to answer whether or not a child could be considered a plus one, or whether or not they're invited at all. Before these questions arise, envision the type of event you want to host and then make a firm decision. To ensure that friends and family don't have to scramble to make it to your big day, include this information on your save-the-dates. If you have just a few friends who are parents, I recommend asking your venue manager whether they have any care sitters who are regularly hired. Most places do, and if this is the case, you can reach out directly to loved ones with small children and explain that, while it's not a child-appropriate event, you're offering childcare should they need it onsite.

At my wedding, this worked like a dream. Eight children watched movies in my parents' resort suite, eating food suited for them (and carefully vetted by their parents), under the care of a sweet caregiver highly recommended by the resort. Meanwhile, our friends were able to kick back and enjoy the live band and the delicious wine I'd hand-selected from nearby vineyards, knowing their children were in good hands nearby.

After determining who to invite, one of the biggest challenges a couple faces is the seating plan. I know couples who don't want to have anything to do with that and allow for open seating. This also works well if you don't have a seat for everyone, and your wedding is "reception style" rather than a seated

dining affair. Our venue was intimate and fit exactly 120 seats, so we wanted to curate a perfect combination of personalities at each table. Moreover, we didn't want any table to feel like they had been slighted by not getting to sit with us, so we opted for a sweetheart table where my husband and I sat together and could enjoy the toasts and steal some kisses throughout the evening, tucked away out of the spotlight.

The two rooms of our venue adjoined with open doors, so we strategically placed the band and dance floor in one room, and the cake in another so that guests in each room would have the opportunity to be up close and personal for the various activities that would transpire throughout the evening.

When it comes to seating people, think about what guests might have in common. Maybe your aunt who went to Stanford would enjoy sitting next to your husband's friend who also attended the university or grew up in Palo Alto. Perhaps there are two single guests both in from Los Angeles, who might make a lasting friendship if you sat them near each other. We still hear years later that people who met at our wedding have become close friends, and we've also experienced this at friends' weddings, so take it upon yourself to work as a connector for your guests. It also never hurts to run your seating plan by your parents or a few trusted family members who know many of the wedding guests. In my case, I was unaware of a few intricacies that could have caused awkwardness, and was able to carefully re-arrange the seating plan with some additional insight from my folks.

When it comes to setting the tone for a wedding, it begins with the very first communication with your guests. My wedding had an elegant, vintage theme, and the invitations reflected this from the material Garrett and I chose for the card stock, to the filter we set on the engagement photos. Setting up a wedding website and including the URL on invitations can prove helpful, too. If you choose to do this, make sure to match the mood and level of formality of your wedding to your website. This way, guests can choose their attire appropriately and know what to bring to enjoy your venue's surrounding area. Remember, your wedding, like any event, should unfold like the narrative of your relationship and remain consistent and cohesive from the first touch point to the final guest amenity and thank you card.

While Garrett and I are both somewhat traditional, we also like to create unique experiences and wanted our wedding to embody our values *and* be a really fun party for our guests! We thought through what factors might turn into pain points for guests, and did away with them early on. We took the moments that we know everyone loves most and front-loaded them during our ceremony, so people would enjoy and remember these before they'd had a few too many glasses of wine.

While the wedding ceremony itself is one of the most important aspects of the event, it can be dreaded by guests as it may tend to drag on or feel rote. On the other hand, people love toasts at weddings because they are personal and entertaining.

So we asked five of our best friends (all great writers and speakers, and highly entertaining) to speak during our ceremony. We assigned each of them a core value of ours (humor, style, benevolence, love, friendship) and had them speak about how we embodied these values. Some were touching to the point of drawing tears, while others were so funny they could have been performed as stand-up comedy. In short, it infused a dry ceremony with wit and content that was meaningful to us, and also helped our guests get to know our values as a couple. We simultaneously agreed we weren't a fan of weddings where guests are made to wait around for hours while the wedding couple takes photos. So instead, we took care of that before the guests arrived and then hosted a really lively, happy hour replete with a wine tasting of Napa's local favorites paired with delicious oysters, canapes, live jazz, and views of the valley. This gave our guests a chance to mingle with each other before sitting for dinner, and we had a chance to socialize with our guests before the rest of the more-formal festivities unwound.

When Garrett and I chose to have our wedding on the property of Auberge du Soleil, one of Napa wine country's idyllic resorts, I knew the setting came second to none. Sure enough, as the sun set behind the green backs of vineyard hills, our guests expressed to us that experiencing the location itself was their vacation of a lifetime. The resort sits among thirty-three acres of sunlit olive groves, on the slopes of Rutherford Hill. Surrounding the resort, guests could

enjoy hiking, cycling, wine tasting, and spa treatments with the most majestic views of Napa Valley. After being treated to a wonderful evening of dinner, drinks, dancing, and the chance to partake in a most intimate experience, guests certainly didn't expect a gift from us. However, we liked the idea of providing a memorable giveaway treat at each guest's place setting, so we had a renowned pastry chef at the local French bistro Bouchon (where we got engaged), create a small army of macarons in our wedding colors, eggplant and dusty rose pink. The baseball-sized cookies sat inside custom-made boxes topped with a black-and-white sticker with a photo of Garrett and me in a Napa vineyard.

We played up the Napa theme in other ways as well—each table featured a black-and-white photo of us at one of our favorite wineries which also inspired guests to visit them for tastings during the following days of their Gaudini wedding stay. Since we wanted to remember our wedding and capture the general feelings of our guests, we had people write on a giant framed photo from our engagement shoot, also taken in a vineyard setting. Guests also wrote personal tidbits on marriage and life on slips of paper and tucked these into an enormous jeroboam-sized empty wine bottle, which we had opened at our rehearsal dinner the evening prior. Thanking the members of your wedding party and your parents (or anyone else who contributed to your wedding) is a thoughtful gesture every couple really should take time to make. Using the same guidelines I set for corporate events, I

don't give gifts just to "gift," and instead, I was thoughtful about customization for the thank-you tokens I bestowed upon my bridesmaids. They each received a silky robe in dusty rose with their name embroidered in black script writing, so we would not only be comfortable and glamorous, but also cohesive during the pre-wedding photos taken in my hotel suite as we all got ready together. I also gave them each a special pair of unique, vintage earrings that would match the style of the event, and complement everyone's dress, completing the polished look I had imagined many months earlier. I also made sure that anyone who wanted hair or makeup done received a complimentary session with one of the stylists; most importantly, I included a handwritten note thanking each of them for being such an important part of my life and my special day.

As starlight twinkled outside floor-to-ceiling windows inside the spacious wood-beamed room, guests savored the two unique cake flavors a famous chef had artfully imagined for Garrett and me. There was savory banana cake, with caramel cream cheese frosting, and another that boasted rich flavors of decadent toffee, chocolate, and mocha. We'd eaten our way through thousands of calories worth of cake tastings in order to find the best vendor in Napa (fun fact: the vendor we selected also created the cake for Tom Cruz and Katie Holmes and Christina Alguilera's weddings!). The "hard work" paid off when we realized the cake was so popular we barely salvaged one last slice to save for our one-year anniversary. At the

end of the night, I felt a deep well of gratitude for the people in my life and, of course, the most incredible life partner I could ask for. The truth about hosting a truly-successful event is evidenced when you stand in front of more smiling faces than you have birthdays, and realize the extent of your vision has become even sweeter in reality's light.

In the future, AI will be used to alleviate industry pain points and enhance personalization.

-Gianna

What to Expect in the Future

When I think about the future, it might surprise you that my first thought doesn't go to technology, but rather to sustainability, so that we will have a beautifully preserved planet for our children and their children. As event planners, we have a responsibility to focus not only on the community we are hosting inside the event venue, but to show respect for and give back to the community in which the event takes place. If you're hosting a large conference in a metropolitan area, aim to make the locale better than when you left it rather than disrupting the city with added traffic (and hence pollution), road closures, and waste. When planning an event, think about sustainability before you even determine a venue or event location. Consider how far attendees will have to travel by plane or ground vehicle to get to the destination. Ideally, plan an event that limits air travel, and if there is substantial travel involved, consider purchasing carbon offsets. When selecting a venue for

an event, look for venues that are LEED certified (like the Moscone Center in San Francisco). When hosting an outdoor event, try using sustainable power sources like solar or sustainable biodiesel. When planning the fabrication and rentals for your event, consider the materials you're using and how you're shipping event properties to the venue. Can you used recycled or reclaimed materials rather than new ones? Can you eliminate any shrink wrap used for shipping by using shipping blankets? It goes without saying to make sure you limit the number of trash cans at your event and supply more recycling and compost bins. There are organizations (I use Green Mary in San Francisco) that you can hire locally who will help sort refuse and even help educate your attendees on how to properly dispose of their waste. Finally, consider who you hire to support your event. I always inquire about sustainability practices when evaluating an RFP for caterers and agencies and hesitate to hire those who do not have these standards in place.

A result of the "always on" society in which we live today is a renewed focus on the importance of mindfulness and wellness. Thinking like an attendee, wellness is especially challenging to maintain when traveling. Events can be overwhelming, especially when people are away from their jobs and families, trying to juggle it all while remaining present. I like to offer healthy food options like fresh, local produce and proteins, fruit-infused spa waters, and healthy snacks

available in a "micro-kitchen" that rejuvenate people throughout the day. I've incorporated breathing techniques, yoga, and meditation into sessions to break up the heavy content, which is often a welcome and refreshing break. Meditation rooms and massage lounges are rising in popularity, as are group activities such as a morning yoga or hike, to help keep attendees feeling at their peak and fully engaged at the event while building community.

As the event planning industry continues to evolve with increasingly complex experiences, new solutions are forming that will help planners rise to the heightened expectations of attendees. Although we face an ever-present reality of higher workloads and tighter time constraints, around us, solutions percolate for every part of the planning cycle. We are in an era of innovation, but in order to be successful, we must follow consumer attention and use the tools that benefit both our teams and our attendees. This means understanding which trends will last and which will fade—yesterday, it was the six-second video app Vine and automated messaging; now it's Instagram, virtual reality, and customized event apps.

We know that the origin of any great event begins with a motivated audience, so when we're confident about lasting technology, we can reverse-engineer pain points and use it to shape our solutions. We also need to think about the bigger picture: Are we truly delivering diverse content? Does our venue have accessible entrances for everyone? Are we spreading more than just product awareness, but our company

culture and beliefs too? The best way to maintain relevance is to read, listen, and constantly absorb. When the future beckons, it's your job to take charge and move with it.

When we look to data, all conclusions point to a more prolific use of technology within the event industry. A study from Enterprise Event Marketing found that the use of technology can create a twenty percent increase in event attendance while reducing related costs by up to thirty percent. Conversely, one of the biggest reasons event professionals don't use new technologies is due to costs—but this much is changing. As technology improves, event management and planning products will integrate and SaaS models (software as a service) will be offered at a limited cost or even free of charge. One integrated technology to look out for is event diagramming software. Diagramming has been around for a while, but now planners are able to complete their venue diagrams by dragging-and-dropping virtual props, constructing 3D walkthroughs, and designing different levels of comfort seating, all on the same platform. Within the next two years, planners will be able to construct virtual attendee experience simulations, too. A number of companies have platforms that offer much of the aforementioned, but I take note of the ones that offer their services for free.

The web based app, Social Tables (part of Cvent), is one example; the event diagramming company allows users to accurately create to-scale diagrams in minutes, and centralize communication between team

members. Diagrams can easily be shared with venues, clients, and collaborators. Planners can also manage guests, from VIPs to special meal requests, and visually seat them in the diagrams they create. There's no harm in trying a free version of the SaaS, so go for it! With so many tools cropping up these days, I recommend using a structured product evaluation process to determine whether a solution is a good investment for your team's unique needs before purchasing it. Stay focused on your core use cases for what it must do and don't get mislead by shiny features that may even distract your attendees from why you wanted the app in the first place.

We can all agree that apps have become an integral part of how we function in daily life, so it comes as no surprise that this is also true for our industry. We will likely see a rise in event apps, since they provide limitless opportunities to interact with consumers while providing helpful information to attendees. Apps can be customized to appear as if they were created specifically for certain occasions, while offering functionality that enhances and personalizes the attendee experience. I encourage planners to study the proliferation of artificial intelligence, since AI will be used to alleviate industry pain points within these applications. AI-powered concierge apps are prolific in the hospitality industry already and come in the form of digital assistance, voice-activated hotel check-in agents, and travel experience enhancers. Since human interaction is so vital in our industry, it's likely that we'll see a higher

frequency of concierge apps that also incorporate person-to-person interaction. Attendees will use their digital concierge to ask questions, and the AI will handle their requests or flag a skilled worker nearby at the event. Should a guest want a cappuccino, they need not wait long—their AI-powered devices will make the necessary request, and soon the beverage will appear. A recent study by American Express reported that 9% of Americans would spend more with brands that provide superior customer services, which bodes well for the digital concierge industry, so expect to see more of these types of solutions. The event planning industry will not become entirely reliant on AI-powered apps anytime soon, though, so we will still need day-of-event staff for set-up, catering, and of course, general friendliness and face-to-face interaction. However, AI management services will begin handling the bulk of incoming requests from guests, so that employees can better focus on the tasks that require human sentience.

Not only will guests begin to create their own in-seat on-demand snacks and beverage schedules, similar to the Virgin airlines model, but they will also help shape the content they consume, too. Attendees have been suggesting speakers and topic ideas for a while now, but their influence will continue to grow. Most event registration platforms or websites are currently set up so that attendees can pre-select the talks they want to attend, and if sessions don't attract enough people, they're dropped from the agenda or

can be moved to a smaller room within the conference.

This is only level one; the next level is total audience engagement. This requires planners to pose more questions to attendees ahead of time on social media or via live polling. On a personal level, you can get involved by reaching out to audience members on industry-centric LinkedIn groups and asking challenging questions that make viewers think deeply about what they want from your event. You can preface these questions with a few lines regarding what your brand would like to communicate, and if commenters express different viewpoints, I encourage you to explore these further. These dialogues will serve as great intel when curating event content.

A number of new companies have cropped up for this very reason—Mentimeter, Glisser, and Buzzmaster, to name a few. Buzzmaster is a particular industry favorite as of late, since it fosters interactions with talented thought provokers and audience members in real-time. The "BuzzMasters" are all journalists or experienced event managers, who pose unexpected questions to the audience as the event unfolds, helping to facilitate sessions and create a buzz. They also sort through data and curate the most interesting comments during and after the event and find the best stories to share. Tools like this typically have a feature that sends tactful push notifications to communicate with audiences. According to a study by Localytics, 52% of smartphone users have push notifications enabled on their devices, which means half an audi-

ence can be reached during an event, and driven towards purchasing decisions or other actions.

Of course, as with all things, moderation should be practiced when interjecting into the attendee experience, even with goodwill tech. The reality is, we live in a world where marketing infiltrates every part of our lives, and there's a fine line between spamming and informing our guests. Sending push notifications to inform an attendee of a newly opened session that matches his or her profile can certainly prove helpful, but studies have shown that sending an attendee more than ten push notifications in one day has negative effects. You certainly don't want to drive anyone to disable their notifications since it's a quick way to communicate need-to-know updates, so be ultra-selective when planning push-communication and be sure to put in some "per user limits." If it's obvious that you're delivering value to your audience members through the form of promo codes for discounted meals and swag, than push away. But remember, when someone installs your event app, they are trusting you. It's up to you to keep that promise.

In the darkly comical indie film, *Ingrid Goes West*, a young woman becomes infatuated with an Instagram-famous blogger named Taylor. Ingrid becomes so entranced by Taylor's seemingly flawless life, she starts mimicking Taylor's every move. When Taylor posts a picture of her breakfast at a bagel place, Ingrid stops by the same joint later in the day. Taylor quotes a passage from her favorite book, and Ingrid orders it right away. The events depicted in the film might be

hyperbolic for cinematic purposes, but they aren't too far off from reality. Influencers have played a role in promotion for a while now, and their eminence isn't fading. Artisanal avocado toast will eventually not be the most popular food posted on social media, but influencers have changed the way brands think about marketing and promotion and look to be around for at least a little while longer.

Since consumers have unlimited freedom and choice over the content they view, brands struggle to target their audience members over a growing number of platforms. For this reason, influencers who have considerable reach now have a monetary value that can be worked into planning budgets. As of 2019, an Instagram influencer's monetary value is calculated at $1,000 per 100,000 followers. YouTube sensations are said to be worth $100 for every 1,000 views they receive on videos. I recommend taking a look at companies like Traackr, Klear, and HYPR to help you evaluate which influencers will represent and serve your brand best. When an influencer embodies your brand *and* has great reach to your target demographic, you'll be able to inspire attendees to look further into your product or services by working with the influencer to produce captivating content on a new medium. When done right, this attributes credibility to your brand and gives your upcoming event organic exposure through the influencer's top channels.

On another note, companies should be increasingly aware of accounts that are propped up with purchased fake followers. The goal of influencer

marketing is to find digital celebrities who have all obtained an organic following and appreciate a steady growth rate. Brands should partner with people they believe embody a similar ethos and style. Since Instagram deleted bot accounts in September, 2016, the influencers who purchased fake followers saw a sharp drop in "popularity." A number of companies were established to detect whether influencers have had any unnatural drops or large, sudden bumps in followers. InstaCheck, for example, is designed to detect fake accounts by analyzing a user's engagement, spam, and overall activity growth. If it seems like the influencer continued to purchase fake followers in the aftermath of the Instapurge, InstaCheck will highlight this. When evaluating an influencer, it's helpful to understand growth rates yourself. At or below 2% is considered poor, while above 7.5% is very good. You can see why a growth rate of 61.6% seems completely unrealistic and suspicious. Of course, if an account becomes popular after the owner does something to produce a viral response, it's a different story. For this reason alone, doing a preliminary online search on top candidates should be the first step you take in this process.

Another growing trend in the event planning landscape is the use of projection mapping. Imagine entering a convention center and being totally immersed in a rejuvenating experience: you hear the sweet sounds of birds and crickets, and even feel the warmth of sunshine on your skin. Instead of registration tables and flat walls, you see a colorful forest growing before your eyes—greenery of all shades,

swaying flowers and shrubs, flitting wings from lovely birds. Is it a mirage? *No!* It's an augmented reality experience, created by an intricate array of projectors and a state of the art sound system.

Devices can now light up practically any surface and turn everyday structures and building sides into 3D interactive displays. Projection mapping helps us event planners incorporate truly transformational design elements into any space we see fit. It cuts the cost of creating scenic wall displays, and can create entertaining distractions for guests if they're waiting in line. Some venues have started projecting scenes of dancers and acrobats as attendees wait to be seated. The whole process of creating the mapping is sort of like painting with light: designers can add textures, colors, and imagery to the entirety of an environment. Practically anything can be projected—from sponsor carousel branding, to cinematic narratives that include subtle advertisements for products. Because there are no real limits to what you can do with projection mapping, event planners are free to stretch their imaginations and come up with truly inventive displays. Whether it be a 3-D map of sponsor booths, a social media wall, or an interactive art display, the technology is flexible enough to meet a variety of objectives.

Furthermore, venues themselves can also benefit from projection mapping. While many event venues offer audio and visual equipment, most do not offer creative solutions to the most common challenge faced by event planners: space customization. Adding

projection mapping enables venue managers to create unique experiences without physically altering the venue itself. This is already happening at the Sydney Opera House, courtesy of the artist Jorn Utzon, who has created an overwhelmingly popular initiative to give the building human expression. Right now, the venue is decked out with projection mapping and features new, jaw-dropping transformations daily. Any non-white and non-flat surface shows advertisements, art videos, and decorations. In other parts of the world, regular run-of-the-mill conference spaces now boast projected windows that show views of world-famous buildings and natural wonders. Venues can charge a lot more for their space with views of the terraced gardens of Capri, or even a close-up glimpse of the pockmarked moon, than those who still sport plain, uninspired walls.

Finally, we thankfully hear the words diversity and inclusion far more than we did ten years ago, but we still have a long way to go with this important initiative. There's a lot that event organizers can start doing right now to exceed societal expectations and facilitate truly inclusive experiences. Bringing in more attendees from different backgrounds means bringing a diverse array of insights into the event space, too. After all, diversity is much more than race and ethnicity. We need to think about it this way: It includes people of different ages, physical abilities, genders, education levels, and more.

Fortunately, at every step of the event organization process, there are more opportunities than ever

for event organizers to promote diversity. At the event registration screen, for example, give attendees the option of choosing a gender neutral prefix (Mx.), in addition to the standard options of Mr., Mrs., or Ms. The addition of a checkbox is by no means a final point since it simply serves to identify some members of the community. In terms of taxonomies related to gender, sexuality, and so on, including this step is just what some expect to see. One of the best ways to make diversity front and center at your event is to dedicate a session or panel to it. In fact, diversity panels and sessions have become increasingly popular in recent years. When holding them, there are several things to keep in mind:

Make sure that your panel speakers are involved with other programming as well and not simply invited, as this can be perceived as "tokenism."

Be deliberate with your diversity programming—asking why diversity is important should simply start the talk off.

Probe deeper with content beyond diversity, career, and work-life-balance.

Above all, think of how you can extend the conversation outside of your event and into future discussions. The conversations shouldn't just stop once the session ends. Try making room for additional dialogue in vibrant online and offline event communities. Being truly inclusive means going above and beyond simply sourcing diverse speakers and targeting a broader attendee demographic.

Make it a goal to bring on more diverse vendors

to support your event, from small local caterers to women-owned businesses. These vendors will likely add more authenticity to your efforts and offer a unique perspective to enhance your DEI (diversity, equity, and inclusion) programming. At a Women's Leadership conference, I made sure to hire all women-owned vendors, from caterers and the production agency, all the way to the photographer and miscellaneous contractors. During the conference, when one of our senior female leaders interviewed a famous young YouTube performer, she actually commented on how cool it was that the sound engineer was female. She said she'd never worked with a female sound engineer, but was inspired by the level of thought we put into our inclusive staff. When you're focusing on serving an underrepresented demographic, make sure you have people on your team who identify with them, so you can gut check all your event decisions and make sure they will be positively received by attendees.

Technology and consumer expectations will continue to evolve, but certain fundamentals will always remain. As people engage with companies across industries, their expectations for what constitutes a good customer experience stays grounded in the obvious: People want to feel like they've been heard, inspired, and educated, and that the company involved genuinely cares about them.

In the coming years, experts will figure out how to incorporate personalization into all facets of an event or experience: how to bring together disparate data

sources, how to deliver one-to-one experiences that connect across channels, and how to leverage machine learning to power truly personalized concierge service. Now that the one-to-one dream is attainable, we will see this filter throughout our own organizations, too.

With 80% of event planners saying their jobs encompass more experience creation than just two to five years ago, we shouldn't feel overwhelmed by all the new technology available, but rather embrace it, and lean into its presence. Think about it this way: As complex as machine learning, facial recognition, and data algorithms are, the purpose of any one of these trends is not to intimidate us, but to enhance our capabilities and the experience for our guests. Whether we achieve richer experiences via technology that enhances the attendee experience or maximizes the way we spend our time as planners, or by standing behind socially responsible initiatives that matter to our audience, these movements are elevating standards and empowering the industry to push the boundaries of face-to-face experiences.

It is within your capability to create the most memorable experiences possible.

-Gianna

Conclusion

By now, you have an idea of what it takes to craft successful events and hone these skills into a thriving career. There are so many paths this unique field may lead to, and I hope you are prepared for an exciting and fulfilling journey. When creating experiences that will touch people and make lasting memories, I challenge you to try something new and push the boundaries of experiential engagement. It is within your capability to create the most memorable experiences possible, leaving impact long after guests have said their final goodbyes.

While much of this book outlines my professional career, I believe event planning affects everyone. Reflecting back on my own life, many of my memories are anchored by events; birthdays, holidays, weddings, baby showers, celebrations, dinners, and graduations... memories are a universal part of being human. I sometimes think I'm a "memory weaver" with each event I plan, be it a dinner at my home, or

a conference for 30,000 people, creating a fabric that is rich and textured. Virtually everyone will attend an event or host an event at some point in their life, and my overarching principles are the common thread that ties them all together.

If I've inspired you or taught you something you find useful, please share my book with the people you care about in your life. Friends, families, college friends, colleagues. Anyone who can benefit from being able to better design their life and the events that help cement key moments forever. Remember, you are the event planner of your life!

I love hearing from readers. If you'd like to get in touch, you can find me at Giannagaudini.com. Send me a note! Who knows, perhaps we'll plan an event together someday. And, if you liked this book, please help support me by leaving a review on Amazon, Goodreads, or Bookbub.

Acknowledgments

This book would not exist without the support of my tribe. Thanks to all of my pre-readers, proofreaders, and fellow authors who helped with the launch of this book. A special thanks to Simone Drucker and Christian Pfrommer, for designing the beautiful front and back cover of this book. To Sarah Deragon, my photographer who captured all the photos for my website and book cover brilliantly, and to the SF Design Center Galleria for hosting our cover shoot. To Erin Brennan, my brand strategist and advisor for helping me grow my platform. Elaine Cardinale, you've instilled in me a passion for hospitality, design, and caring for every last detail. Many of the memories I have are attributed to the care and effort you put into every holiday, birthday, and dinner at our home; your thoughtfulness and generosity is second to none. Rex Cardinale, my lifelong mentor and most inspirational person I know. Thank you for always pushing me to exceed expectations, pursue my passions, and

live my best life. I might not have found my career path if it wasn't for the time we spent together doing career exercises and discussing possibilities on long walks many years ago. Camille Cardinale, my talented sister, thank you for helping advise me on building a business, and most of all, to supporting my family with all of the love and care you give to little Giacomo. And most of all, to my husband, Garrett. You have always inspired me to be the best version of myself and reach for goals that I never thought possible. Your support, trust, and daily reminder to stay grounded in what's most important in life fill my heart and home with endless love.